D1505896

SHONEN
ART STUDIO

YISHAN LI WITH YISHAN STUDIO AND ANDREW JAMES

SHONEN
ART STUDIO

EVERYTHING YOU NEED
TO CREATE YOUR OWN
SHONEN MANGA COMICS

Watson-Guptill Publications / New York

SHONEN ART STUDIO

Copyright © 2010 by The Ilex Press Limited

All rights reserved.

Published in the United States by Watson-Guptill

Publications, an imprint of the Crown Publishing Group,

a division of Random House, Inc., New York.

www.crownpublishing.com

www.watsonguptill.com

WATSON-GUPTILL is a registered trademark

and the WG and Horse designs are trademarks

of Random House, Inc.

Published simultaneously in Great Britain by The Ilex

Press Limited, Lewes.

This book was conceived, designed, and produced by

The ILEX Press, 210 High Street, Lewes, BN7 2NS, UK

FOR ILEX PRESS

Publisher: Alastair Campbell

Creative Director: Peter Bridgewater

Commissioning Editor: Tim Pilcher

Managing Editor: Nick Jones

Editor: Ellie Wilson

Art Director: Julie Weir

Senior Designer: Emily Harbison

Designer: Jon Gregory

Library of Congress Control Number: 2009936596

ISBN: 978-0-8230-3332-4

Manufactured in China

First American Edition

CONTENTS SHONEN

INTRODUCTION

THE BOOK YOU NOW GRIP IN YOUR WARRIOR-LIKE HANDS IS AN INTRODUCTION TO THE EXCITING WORLD OF SHONEN MANGA. THE FIRST HALF OF THE BOOK IS CRAMMED WITH STEP-BY-STEP TUTORIALS DESIGNED TO LAUNCH YOU INTO A NEW SHONEN UNIVERSE, FROM CUTTING-EDGE CHARACTER DESIGN AND ILLUSTRATION TO LAYING OUT YOUR PAGES SO THE ACTION FLOWS SMOOTHLY, AND ON INTO THE FUN PARTS OF TONING, COLORING, AND LETTERING YOUR CREATIONS. LEARN THE BASIC RULES—SO YOU CAN BREAK 'EM!

Whether you're new to shonen manga illustration, or an experienced artist looking to become the greatest shonen artist the world has ever seen, this book will give you all the foundation you need!

In your rush to greatness, don't forget the CD embedded in the cover: by using the line-art images included, and following the book's simple step-by-step instructions, you'll be able to create full-color manga illustrations and detailed shonen story pages with ease.

THE HISTORY AND RULES OF SHONEN MANGA

TO THE JAPANESE, "SHONEN" JUST MEANS "BOY," AND SHONEN MANGA IS MANGA AIMED AT BOYS. OVER HERE IN THE WEST, HOWEVER, SHONEN HAS BECOME APPROPRIATELY ENTANGLED WITH THE TYPE OF HIGH-OCTANE, HUMOROUS, AND ACTION-PACKED STORIES SHONEN MANGA USUALLY PUBLISHES.

Whether it's an underdog basketball team overcoming the odds to take home a trophy; a shy junior school kid discovering he's got the chops to front the greatest band in the country; a team of soldiers piloting giant mechs against a vicious alien invasion; a fantasy epic in an alternate steampunk history; a monster trainer trawling the world for new creatures to capture, train, and deploy; a young ninja punching, kicking, and stealthing his way to the top; or even a trainee chef deploying his secret, homemade recipes to debilitating effect, shonen is all about passion, integrity, friendship—and a character's drive to be the best in the world at whatever it is that they do!

Shonen manga can encompass anything and everything you want it to, so long as it's packed with energy that blisters off the page and artwork that scorches the retinas of your readers! There are no limits—only opportunities. Shonen laughs at attempts to place it in a neat genre box, so mix up your favorite inspirations and see what comes out.

Shonen manga may seem relatively new—and the fact that it's always fresh and right at the edge of art techniques may have something to do with that—but its twisting roots go all the way back to the 19th century. Shonen springs out of the carved-woodblock school of printing. Back then, the unofficial founding father of manga, Hokusai, brought life to everyday scenes that were transferred to paper and shopped round the provinces in a printing process known as ukiyo-e.

Although Hokusai was the first to use the term "manga" in this way, it was thanks to another man, Osamu Tezuka, that shonen burst into the lively and action-packed storytelling form it is today. Influenced by Disney and his own incredibly fertile imagination, Tezuka created hundreds of characters—among them Astro Boy—and pioneered dozens of new techniques that caused scenes of speeding spacecraft, battling robots, and long-lost jungles to whirl out of the page, even in black and white.

Under his influence, and with the rich, post-war imaginations of his friends and colleagues, shonen manga made a quantum leap in quality and popularity, shattering into the dozens of thrilling genres and thousands of stories we know and love today.

Today, there is a manga for everyone, especially those in search of adventure, danger, titanic stakes, and great romance! So lock and load, shonen fans, as we open the door to a universe of adventure, with you in the driving seat!

SHONEN

ON THE DISC

On the CD you'll find a huge variety of shonen characters, sidekicks, weapons, monsters, and accessories: everything you need to kickstart your imagination and let you jump straight into the creative business of putting a story together. We've done most of the hard work for you, so you can set up your own characters, locations, and page layouts in a matter of minutes. It's as simple as selecting the looks you want, assembling the sections of line-art you like, and then transplanting your finished creations into one of the provided page layouts, where you can add colors, graytones, and speech balloons to give your project the professional touch.

Use the provided illustrations as building blocks to create your own characters—you can then add color or tones digitally, or print off your linework and use inks, pencils, or paints to bring your pictures to vibrant life. The CD enables you to create an assortment of shonen heroes, allies, and heroines, with a variety of faces, hairstyles, clothes, weapons, and expressions. Get your imagination into gear and dive right in!

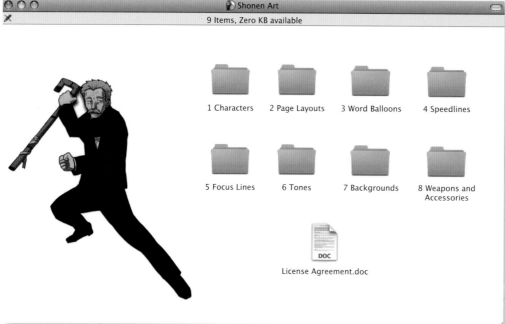

Shonen Art
9 Items, Zero KB available

1 Characters 2 Page Layouts 3 Word Balloons 4 Speedlines

5 Focus Lines 6 Tones 7 Backgrounds 8 Weapons and Accessories

License Agreement.doc

ON THE DISC
1. Characters
2. Page Layouts
3. Word Balloons
4. Speedlines
5. Focus Lines
6. Tones
7. Backgrounds
8. Weapons and Accessories
License Agreement

TAKING IT FURTHER

There's no need to feel constrained to using the line-art provided on the disc. When you reach the limit of what you can accomplish with the art provided, you'll probably find yourself ready to take the leap into drawing your own characters, accessories, or backgrounds, and you'll find that, by scanning your art in, you can seamlessly integrate your creations with those on the disc. When you feel confident enough, you may even want to create an entire cast of characters and a stunning shonen comic from scratch. Either way, you'll be able to use this package to gain experience and insight into how shonen characters and pages are put together. Enjoy yourself, pour your creativity into the raw resources supplied, and transfer that crazy energy straight onto your pages!

SHONEN

01 //
DIGITAL MANGA

THE DAWN OF THE DIGITAL AGE EXPLODED ALL THE OLD PRECONCEPTIONS ABOUT WHAT MANGA WAS AND WHAT IT COULD DO. IT ALSO BROUGHT THE TOOLS OF MANGA CREATION OUT OF THE MANGA-KA'S REMOTE STUDIOS AND INTO THE HANDS OF ANYONE WITH A MIND FULL OF IDEAS—AND A COMPUTER! ARTISTS CAN NOW CREATE SHONEN USING JUST A COMPUTER, AND CAN SELF-PUBLISH ON THE INTERNET. THIS CHAPTER COVERS THE CREATION OF A GREAT SHONEN STORY, FROM FRENZIED START TO EXHAUSTED FINISH, ALONG WITH THE DIGITAL PROCESSES BEHIND PROFESSIONAL MANGA—INCLUDING THE BASIC PHOTOSHOP TECHNIQUES USED BY THE PROS.

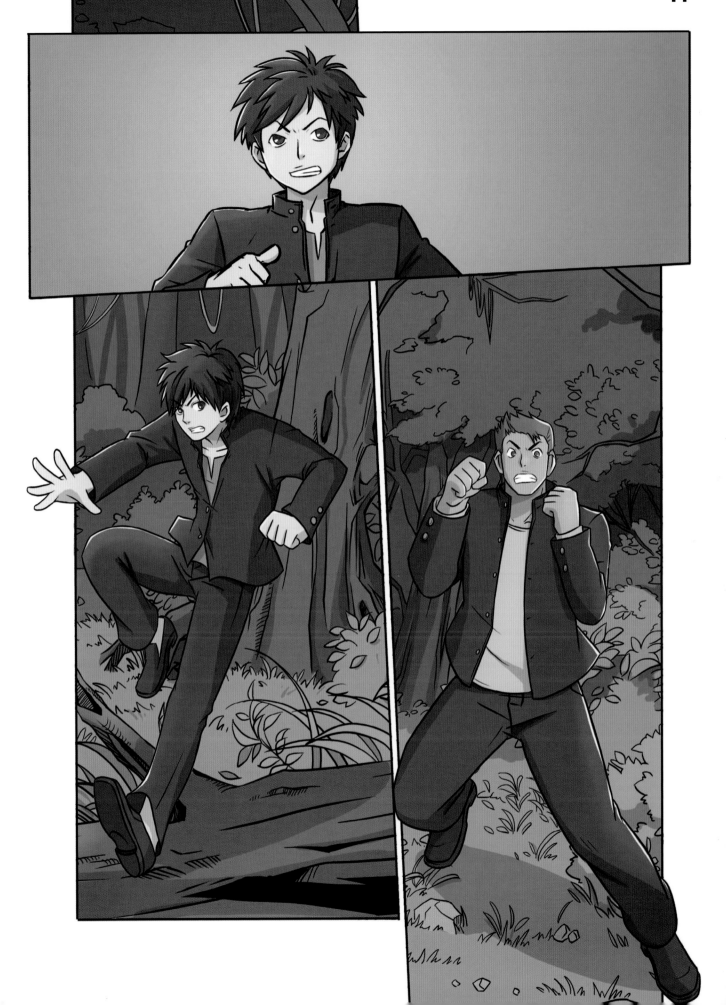

SHONEN

INTRODUCTION TO DIGITAL ART

COMPUTERS HAVE REVOLUTIONIZED THE WAY ARTISTS WORK, MAKING IT EASY TO CREATE PROFESSIONAL QUALITY IMAGES BY PLACING POWERFUL AND ADAPTABLE TOOLS AT EVERYONE'S FINGERTIPS. FAST, HIGH-QUALITY COMPUTERS ARE ALREADY A FIXTURE IN MANY HOUSEHOLDS AND CONTINUOUS IMPROVEMENTS IN SOFTWARE COMBINED WITH EVER MORE POPULAR ART-FOCUSED PERIPHERALS MEAN IT'S EASIER THAN EVER BEFORE TO CREATE FANTASTIC MANGA ARTWORK.

TECHNOLOGY MARCHES ON, AND WITH IT COMES POWERFUL APPLICATIONS LIKE PHOTOSHOP TO TURN TO OUR ADVANTAGE. YOU MAY ALREADY HAVE ACCESS TO MOST, IF NOT ALL, OF THE EQUIPMENT SHOWN ON THE OPPOSITE PAGE. IF NOT,

YOU CAN GRAB MOST OF IT RELATIVELY CHEAPLY. EVEN PHOTOSHOP IS NOW AVAILABLE IN A CUTDOWN FORM, CALLED PHOTOSHOP ELEMENTS, WHICH FOR THE PURPOSES OF THIS BOOK WILL LET YOU DO EVERYTHING THE FULL-FLEDGED PROGRAM CAN DO. ELEMENTS WILL ALSO SHOW YOU THE COLOR-CODED LAYERS WE'VE USED TO MAKE THE CREATION OF MANGA CHARACTERS AS EASY AS POSSIBLE, THOUGH IT WON'T LET YOU CHANGE THEM. FROM A PROFESSIONAL PERSPECTIVE, THE FULL VERSION'S CMYK FACILITIES AND MASKING TOOLS ARE INVALUABLE, BUT AT HOME YOU'LL BE ABLE TO DRAW, COLOR, AND HAVE FUN WITH EITHER.

INTERNET

The Internet is an awesome venue for trading tips with other shonen enthusiasts, but it also makes for a great place to display your finished artwork and storylines. As well as immediate feedback from fans, it's also possible to get more detailed advice and support when trying to improve your skills. Looking at other people's work can inspire you or offer new techniques, especially in the realm of computer coloring, and it's often possible to ask your favorite artists questions about how they put pages together. Make the most of this great resource and allow the whole world to see your shonen creations—the best place to grow up as an artist is in public!

MOUSE

Every computer comes with one, but it's worth checking you have one suited to the task if you're intending to use it for artwork. Grab yourself a laser- or LED-based mouse, as they have increased accuracy—and less likelihood of clogging—than a ball-based model. Their only drawback is a pickiness over the surfaces they run on, but as long as your desk isn't made of polished glass, you should be fine!

GRAPHICS TABLET

The next step up from using a mouse, a graphics tablet will take your computer drawing and coloring to the next level. You'll have to practice to get the hang of a new technique, but it's well worth the effort. Many different brands and types of tablet are available. When buying one, consider the software that is bundled with it, and whether or not the pen requires batteries: if you can, try out a friend's model before you buy, or try to get a feel for your chosen model in the shop. You may have to pay a little extra for a popular brand, but you can be assured of their quality, reliability, and often greater sensitivity than cheaper models. Make sure you choose a size of tablet appropriate for your workspace.

INKJET PRINTER

Color printing at home is perfect to show you previews or even finished pages of your creations on paper. Even low-cost printers can now create good-quality prints (although they may guzzle ink to do so), and you can ramp up the quality significantly by using photo or textured papers. Don't forget that certain colors will look different on paper than on a monitor: purple tends to mix differently in ink, and brighter blues and yellows will also shift along the spectrum. But don't worry—your pictures will still look great regardless!

LASER PRINTER

Picking up a laser printer is far more of an investment than an inkjet printer—if you can get access to one at school, college, work, or your library then try running your shonen pages out there. The more affordable lasers tend to print only in black and white, but they do have many advantages. Lines are often crisper and pages print significantly faster, getting your finished work in your hands all the quicker. Most important from your perspective, the ink from a laser is waterproof and alcohol resistant: pages can be handled without risk of being smudged, which is great if you're producing your own comics to distribute or sell—it also means you can break out the markers and color over your prints, without risk of the ink running. Inkjet inks mix with pens and bleed, although you can combat this by using a photocopy of your printed line-art instead.

FLATBED SCANNER

If you've got the itch to draw your own shonen manga illustrations a flatbed scanner will be essential. With it you can import your black and white (or color) art into the computer for subsequent toning, coloring, lettering, or composition. A scanner that can take letter-sized (or A4) pages is relatively cheap, and all you need at this stage.

SHONEN

PHOTOSHOP AND
PHOTOSHOP ELEMENTS

PHOTOSHOP HAS SEEN OFF ALL OF ITS RIVALS TO BECOME THE STANDARD SOFTWARE FOR DIGITAL ART. ALTHOUGH ORIGINALLY DESIGNED TO RETOUCH AND MANIPULATE PHOTOS, ITS WEALTH OF COOL AND USEFUL TOOLS MAKES IT PERFECT FOR ILLUSTRATION AND COLORING, TOO. THROUGH THE EYES OF A SHONEN ARTIST, PHOTOSHOP IS A GOLDMINE: FLEXIBLE TOOLS THAT LET YOU HANDLE VERY HIGH-RESOLUTION, PRINT-QUALITY IMAGES, ALONG WITH ALL THE FEATURES NEEDED TO SEE A MANGA STORY THROUGH FROM FIRST SKETCH TO LAST PAGE OFF THE PRINT-BELT.

PHOTOSHOP COMES IN TWO VERSIONS: THE CLASSIC IMAGE EDITOR, NOW PART OF THE POWERFUL ADOBE CREATIVE SUITE, AND PHOTOSHOP ELEMENTS, A CUTDOWN VERSION FOR HOME USE. BOTH ARE IDEAL FOR OUR PURPOSES.

PALETTES
Both versions of Photoshop swarm with floating windows, known as palettes. In Photoshop these are held in a Toolbox on the right side of the screen. One of the most useful is the Layers palette, which allows you to switch the different elements of the files supplied on the CD on and off. Do this by clicking the box to the left of the layer: if you see the icon of an eye that layer is visible. A colored bar across a layer shows you which one is currently in use.

PIXELS
(Below) Adobe Photoshop CS4 shown running on an Apple iMac. The larger the monitor, the more room you'll have to spread out your palettes, and the more of your canvas you'll be able to fit on the screen at any one time. You can also zoom in and out of your image, but don't forget to keep checking your artwork at 100% to satisfy yourself that everything looks great at print scale. It's only at 100% zoom that the pixels in your art file are shown at 1:1 scale with the pixels in your monitor. All other sizes show a less accurate simulation of the final printout.

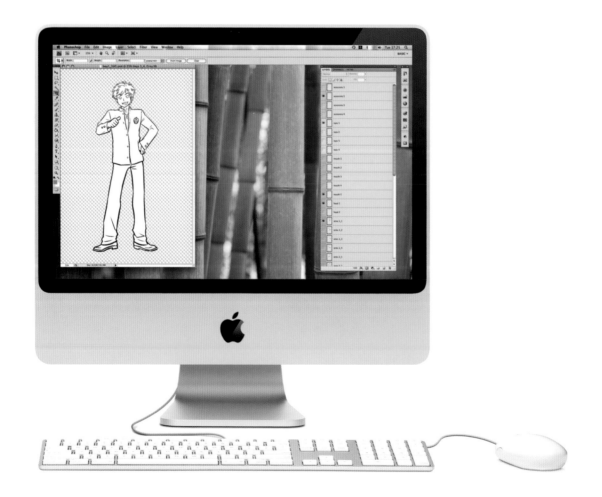

TOOLBOX
Although they differ slightly, both versions of Photoshop have a Toolbox, which, by default, appears on the left of the window. In Photoshop Elements, you might find it docked at the side of the window as a long single column, as you can see here.

TOOL OPTIONS BAR
While the Toolbox provides access to the different tools and functions, the Tool Options bar is where you fine-tune the tool you've selected. If you switch to the Brush tool, for example, this would be where you'd pick the size, texture, opacity, and flow of the tip.

SELECTION AREAS
When working in Photoshop, selections are an easy and essential way to control the parts of the picture that are affected by your painting. A selection is outlined by "marching ants," and any changes you make will only affect the part of the image bounded by that selection. In this way you can isolate and work on specific parts of the image—or specific areas of color—without spilling over into the rest of your picture. Selections are made and defined with a variety of tools—the Rectangular Marquee draws a simple box, while the Magic Wand selects areas of similar color, no matter the shape. Switch the Contiguous option on, and the Magic Wand can be used to select specific areas on your uncolored line-art; turn it off to select all areas of a single color at once. Don't forget to switch off, or deselect your selection when you are finished with it—click outside the selection or choose Select > Deselect to do so.

LAYERS
Layers are one of the most useful and rewarding pieces of high-powered digital imaging, especially if, like us, you're putting your pages together from dozens of different elements. Think of your layers as micro-thin sheets of clear plastic, each stacked on top of one another like processed cheese squares. Each layer has a piece of the finished picture drawn on it—a character, the background, the colors, even—and it's only when you look down on the whole stack that you see the finished piece. Because each layer can be edited, moved around, and tooled about with independently, you'll find yourself experimenting more, and working faster and better, all without the risk of spoiling your underlying artwork. Simply turn off layers if you don't like the results. You'll probably find yourself using more and more layers as you grow more comfortable with them, dedicating layers to specific areas of your image, like shadows and highlights. Using layers is also essential to building your shonen characters from the CD.

SHONEN

PHOTOSHOP TOOLS

THE PHOTOSHOP TOOLBOX CONTAINS EVERYTHING YOU
NEED TO CONTROL YOUR DIGITAL SHONEN UNIVERSE.
IT ALLOWS YOU TO ZOOM IN AND OUT OF PAGES, MOVE
AND RESIZE ASPECTS OF YOUR CHARACTERS AND THEIR
ACCESSORIES, AND RECOMBINE THEM ANY WAY YOU
WANT. HERE, WE CHECK OUT THE MAIN TOOLS IN THE
PHOTOSHOP ELEMENTS TOOLBOX. YOU'LL FIND VERY
SIMILAR TOOLS IN PHOTOSHOP ITSELF—THE ONLY
ONES YOU NEED ARE AVAILABLE IN BOTH VERSIONS.

NAVIGATION
Moving around your documents quickly,
precisely, and easily is the key to working
digitally. Whether it's keeping an eye on the
big picture as you work on a zoomed-in area, or
scrolling from one part of an image to another to
pick up a color you've used elsewhere, navigating
your pictures effectively is the key to success!

NAVIGATOR WINDOW
This window lets you move around a document
quickly without using the Toolbox or keyboard.
This is great news if you're using a graphics tablet
and prefer to keep your hands off the keyboard.

TERMINOLOGY
Occasionally this book will mention time-saving
keyboard shortcuts—and shonen is all about
taking the best route to the top! While the letter
is usually the same, control keys vary between
PCs and Macs, so Ctrl/Cmd + Alt + C means to
hold the keys marked Ctrl and Alt and tap C on
a PC, but to use the keys marked Cmd + Alt + C
on a Mac.

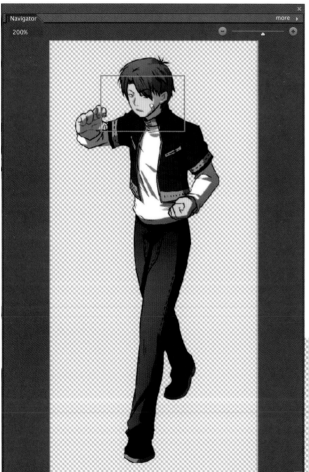

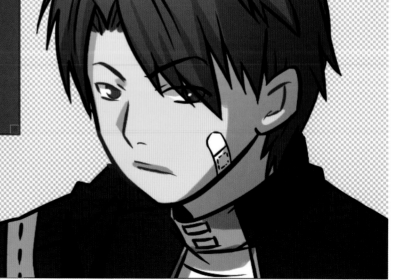

Tip Hold the Shift key when using
a selection tool to add a new selection to
an existing one. Hold Alt to delete from
an existing selection. Look out for the +
and – signs next to the mouse cursor: they
indicate whether you'll add or subtract!

MOVE
Click and drag to move the currently active layer or selection.

HAND
The Hand tool lets you pan (or scroll) around the image without moving any of the items on it. Useful if you're zoomed in to a high degree of detail.

ZOOM
Zooming enlarges or reduces the preview of your image. Holding Ctrl/Cmd and pressing the + and – keys allows you to zoom in and out at any time, without changing tools. Pressing Alt and moving the scroll wheel on your mouse creates the same effect.

SELECTION

Accurate selections net you smooth artwork and color that always stays inside the lines! Luckily for you, there's a great tool for every situation.

EYEDROPPER
The Eyedropper tool changes the foreground color to any color you click on (you can see your current foreground and background colors at the bottom of the Toolbox). Make sure the mode is set to "point sample" so that you always pick the color at which you're aiming. The Alt key temporarily changes the Brush tool into an Eyedropper—and don't forget that pressing X swaps your foreground and background colors, so you can pick up one color, flip, and pick up another!

MARQUEE TOOLS
The simplest selection tool comes in Rectangular and Elliptical form. Highlight a rectangle or ellipse on your document by clicking and dragging. Holding Shift while you click and drag will give you a perfect square or circle.

LASSO TOOLS
If you've a steady hand and great coordination, these tools allow you to select any shape you wish. The Freehand Lasso can quickly and smoothly define a shape with the mouse, but precise control can be tricky. The Polygonal Lasso creates a similar selection, but in this case it draws lines between waypoints you define, and best of all, you can take your finger off the mouse between clicks.

SELECTION BRUSH
The Selection Brush allows you to "draw" a selection directly onto your picture. This brush is exclusive to Photoshop Elements. Photoshop has the Quick Mask feature instead. On this layer, you can use other tools to "paint" the mask.

MAGIC WAND
The Magic Wand tool allows you to select areas of a specific color in the image, which is perfect for applying color to black and white images, and then equally perfect for selecting flat colors for further shading.

PAINT TOOLS

The paint tools are used to draw lines and add color to an image. Different shapes and sizes of brush will affect the way lines appear, and some brushes can create fantastic textures with very little effort. Check out page 18 for an in-depth guide.

PENCIL
The pencil is designed to create pixel-perfect, or "aliased" lines. It works just the same as the Brush tool, only without any blending or blurring around the edges of the line. It's great for fixing gaps in line work, drawing in a "cel-shaded" style (see page 56) or even altering the line-art on the CD.

PAINTBRUSH
The standard painting, drawing, and coloring tool, useful for soft edges and smooth lines. A wealth of style options and brush nibs are available in the Tool Options bar.

DODGE, BURN, AND SPONGE
These brush-like tools adjust the color of your pictures in different ways. Dodge lightens, while Burn makes the color darker and richer. You can shade with these, but most artists prefer to use layers and different colored brushes, as Dodged and Burnt tones can often look harsh or over-rendered. The Sponge tool sucks the color out of an image, gradually turning it gray.

ERASER
The Eraser works just like a normal eraser. On a flat image, it rubs away to the background color. On a stacked layer, it will erase to transparency, showing the layer underneath.

PAINT BUCKET
This tool fills an area with a selected color or pattern, which is great for filling enclosed areas of your images with blocks of flat color. Click on an area and it will be filled to its edges (the point where an area of color meets another significantly different to its own—you can adjust this level of contrast, called Tolerance, in the Tool Options bar).

It can often be useful to select an area on a line art layer first, before filling it on a separate layer underneath. To do this, click with the Magic Wand, set to Contiguous, on an area of your black and white art, then switch to the layer beneath and use the Paint Bucket to fill your selection with color. Painting like this means your original art will never be damaged by mistakes, and it's impossible to go over the lines!

SMUDGE, BLUR, AND SHARPEN
These tools have no color of their own. Instead, the Smudge tool smears the colors around it in the direction you paint. Blur softens the definition of neighboring pixels, and Sharpen increases the distinction between them.

DODGE

BURN

SPONGE

SMUDGE

BLUR

SHARPEN

SHONEN
PHOTOSHOP BRUSHES

WHEN YOU START DRAWING YOUR OWN SHONEN CHARACTERS, OR TWEAKING SOME OF THE ARTWORK AVAILABLE ON THE CD, THE BRUSH AND PENCIL TOOLS WILL BE YOUR MAIN ALLIES IN THE BATTLE TO CREATE AWESOME LINEWORK! THEY'RE THE MOST BASIC, AND YET MOST VERSATILE WAYS OF ADDING LINES AND COLOR TO A BLANK CANVAS. JUST BY CHANGING THE BRUSH SETTINGS, YOU CAN CONJURE A BRUSH THAT IS OPAQUE LIKE PAINT, TRANSLUCENT LIKE A MARKER PEN, OR THAT CAN EVEN REMOVE AREAS LIKE AN ERASER. THE NIB CAN BE BLUNT LIKE A PIECE OF CHALK, SHARP LIKE A PENCIL, OR EVEN VARY IN WIDTH WITH PRESSURE LIKE A TRUE PAINTBRUSH OR NIB PEN. MASTERING THESE SETTINGS WILL GIVE YOU MUCH MORE FREEDOM OF EXPRESSION WHEN TRANSFERRING YOUR CREATIVE IMPULSES OUT OF YOUR HEAD AND INTO PHOTOSHOP OR ELEMENTS.

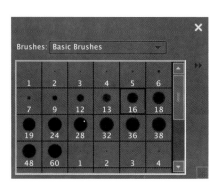

BRUSH
Choose the type of brush you want to use from this menu. Pressing < and > flits through the range of brushes.

SIZE

This adjusts the size of the currently chosen brush. You can use the [and] (square bracket) keys to make your chosen implement smaller or larger.

OPACITY

This changes how transparent the ink or paint will be; 0% would make the paint completely invisible, 50% is half-transparent or semi-opaque, and 100% is completely solid, but you can choose any number in between.

AIRBRUSH

This changes the brush to Airbrush mode, which gives you a gradual flow of paint (depending on the Flow setting). Although this is a useful effect, you may find you have just as much success with a soft brush!

BRUSH SHAPES

HARD BRUSH (1)
These brushes give you a solid shape and smooth outline. Although the edge is anti-aliased (softened), it's still sharp enough to give a convincingly hard line.

SOFT ROUND (2)
These brushes have a gradient of density, and their opacity is reduced toward the edge of the basic shape. Excellent fodder for soft, airbrush-style coloring.

NATURAL BRUSHES (3 + 4)
You can emulate "natural media" like paints, pastels, and charcoal with these irregularly-styled brushes. This style is covered later in the book (see page 62). Explore the menu further, and you'll find all kinds of exotic patterns and shapes that can be used to shake up the "digital perfection" of pure Photoshop coloring.

1.

2.

3.

4.

BRUSH SPACING

A simple setting in the Brushes palette, this can make all the difference to the quality of your lines, as well as your computer's performance. Reducing the brush spacing draws the dots that make up the brush closer together, making for a smoother line. Translucent areas of the brush will appear darker. The more dots drawn, the harder your computer has to work! When you use a graphics tablet, it's often crucial to increase the spacing in order to avoid the line breaking when you quickly move the pen.

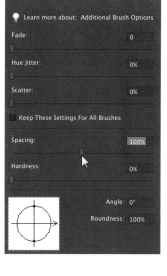

GRAPHICS TABLET PRESSURE SETTINGS

One of the biggest advantages of graphics tablets over mice is that the pen is pressure-sensitive. This little tweak to how you interact with digital media means that you can change the way a Photoshop tool behaves, depending on how firmly you press the tip of the pen against the tablet.

Usually you'll want to set the pressure control to Size when drawing inks and block colors, and to Opacity when shading or adding color. Some more expensive tablets (such as the Wacom Intuos series) also allow for pen tilt recognition, meaning that you can control and adjust additional settings by tilting your pen nearer or further away from the vertical. It all sounds quite complicated, but with a little practice, it will become incredibly intuitive!

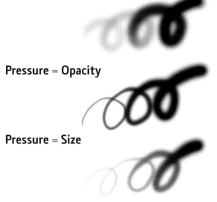

Pressure = Opacity

Pressure = Size

Pressure = Size + Transparency

KEYBOARD SHORTCUTS

QUICK BRUSH RESIZING

The [and] keys allow you to quickly resize your brush (holding down the Shift key at the same time also alters the hardness). This lets you rapidly adjust the level of detail you're working with, without having to zoom out of your chosen document, or shift your focus from a key part of the drawing. This is especially useful when using soft brushes to color tricky areas of your images.

QUICK COLOR CHANGES

When working with the Brush or Pencil tools, you'll often want to change color quickly. By holding the Alt key and clicking over a pixel of the color you want, you pick up that color from the canvas. (You might even want to keep a palette area of dabs of color on your image or a layer within it until you're done.) Also worth noting is the X key, which quickly alternates between your foreground and background color.

PAINTING WITH OPACITY CONTROLS

The number keys along the top of the keyboard act as handy shortcuts for adjusting the opacity of your brush. Press 1 for 10% opacity, 2 for 20% opacity, etc. If you press 2 and 5 quickly, you'll get an opacity of 25%. This is useful if you want to introduce some blending or subtlety to your coloring, but don't want to change color. These shortcuts, combined with the X button, can allow for very fast monochrome coloring!

SHONEN
CREATING CHARACTERS

IT'S SIMPLE AND FUN TO BUILD AN ALL-NEW SHONEN
CHARACTER FROM THE FILES SUPPLIED ON THE CD:
JUST EXPERIMENT WITH ALL THE DIFFERENT WAYS
YOU CAN COMBINE THE VARIETY OF CHARACTER
PARTS AND POSES. THE FILES ARE DESIGNED TO
BE AS EASY TO USE AS POSSIBLE—IT'S REALLY JUST
A CASE OF PLAYING AROUND WITH THE LAYERS
UNTIL YOU FIND THE LOOK THAT WORKS FOR YOU.

1 Insert the CD-ROM from the front of the
book—it doesn't matter whether you're using a
Mac or PC. On the CD, click through to the folder
labeled Characters. Inside you'll find a layered .PSD
(Photoshop) file for each character in this book.
Go to File > Open in Photoshop or Photoshop
Elements, or drag the .PSD file onto the
Photoshop icon to open your chosen character.
The layers within the files are like transparent
animation cels—all you need to do is put all of
the elements together to make a character. To
choose the fragments you want, just turn the
visibility of various layers on and off by clicking
the colored boxes to the left of a layer's name.
A visible layer shows the icon of an eye.

2 In the second half of this book, there's
an in-depth catalog showcasing dozens of
ways you can combine the different layers for
the characters. Check out the sections for each
character to get some inspiration, and to see a
full list of the layers available. To make things
even easier, the layers in the Layers palette are
color-coded. Generally speaking, you won't
want to turn on more than one head, legs,
or torso at once.

3 For quick-and-easy characters, or for simple
projects, you'll be finished here. First, flatten
your image using Layers > Flatten, then save it
onto your computer using File > Save As from the
menu. Don't worry about saving over the original
file—it's safely locked on the CD. If you're going
to be using the same shonen characters a lot, it's
worth setting up a specific folder for each one,
so you can save different angles, expressions,
and poses of the same character and then quickly
access them again when you're compiling your
pages. Alternatively, save an unflattened .PSD
file with the name of each character, so you
can change expressions and the like at speed
whenever you need a new pose.

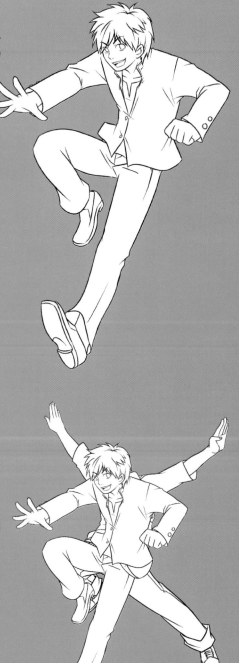

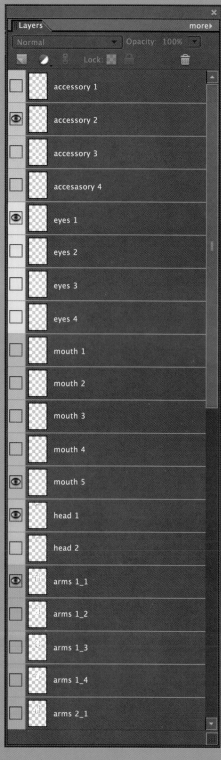

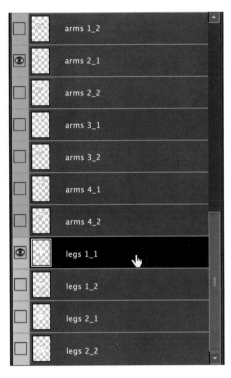

4 The characters' facial expressions can also be adjusted by turning the relevant head layers on and off. A combination of different mouths and sets of eyes will be enough to run the full gamut of emotions! Don't forget that you can exaggerate various emotions by resizing the mouth and eyes using the Free Transform controls, explained on page 23.

5 Some clothing and accessories options may need you to adjust the order of the layers for the best result, or you may want to adapt your character's look by shifting the layers around. The easiest example is of a shirt tucked into trousers (or a skirt as pictured below). To "tuck in" the shirt, just move the shirt layer behind the legs layer by dragging your chosen layers up or down on the Layers palette.

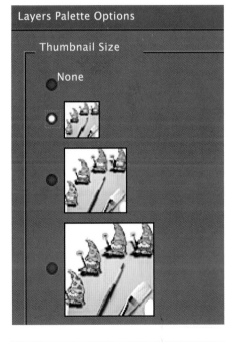

Layers Palette Options

Thumbnail Size

None

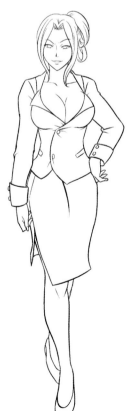

Tip SEE MORE OR LESS LAYERS
To change the number of layers you can see in the Layers palette, you can change the size of (or add/remove) the image preview. Simply click on the More arrow at the top left of the palette and choose Palette options. The larger the preview, the fewer layers will be visible at once.

SHONEN

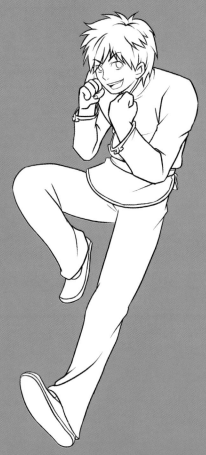

ADDITIONAL CLOTHING

You can expand the amount of clothing your characters can wear in a range of ways, from the simple (adding lines to existing artwork) to the complex (adding new artwork, like an armored breastplate, as a new layer). The simplest way can often be the most effective: just think of how coloring an area differently, or adding lines onto the flattened layers, can suggest a whole range of wardrobe options. You can also create new looks by erasing black lines with the Eraser tool, or using the Brush to color over lines with white.

Try some of these:
* Fingerless gloves (for street fighting)
* Elbow pads (for extreme skateboarding)
* T-shirt logos (for up-to-the-minute slogans for fictional brands)
* Mecha pilot suits (for interfacing with giant robots)
* Goggles or bandages (to disguise the eyes, as a modern assassin or a ninja)
* Bandoliers (for carrying ammunition or micro monster devices)

Don't forget: you're going to be showing your characters from a variety of different angles, so make sure you make the same modifications to all the versions of your character! If you don't, your panel-to-panel continuity will be very confusing, as your heroes sprout and then lose different clothes from second to second...

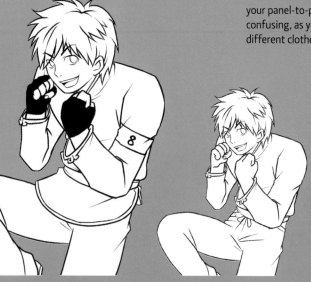

In the first image, simple lines have been drawn on the hands to suggest gloves, and the shape these lines created filled in with black using the Paint Bucket. The second image shows how a new top has been created by just erasing lines.

USING ACCESSORIES AND WEAPONS

The disc also contains a wealth of cool accessories and weapons to add essential detail to your shonen scenes.

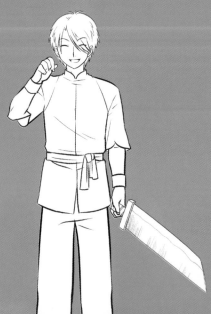

1 Open up the accessory or weapon, alongside your target character image.

2 Drag the accessory layer onto your target image. Alternatively, copy the accessory and paste it onto your target image.

3 Using the Move tool, drag the shape into position.

4 Use the Rotate and Resize functions (explained on the next page) to adjust the shape and dimensions of the accessory.

RESIZING, ROTATING, AND FLIPPING

You can use the Free Transform tool (Edit > Free Transform, or keyboard shortcut Ctrl/Cmd + T) to make your characters even more dynamic, by changing the size and direction of weapons and accessories, the better to blend them with your characters. The only disadvantage of doing so is that you'll anti-alias (soften or blur) parts of your picture: this will cause problems with flood fills at the coloring and toning stage. Don't forget: remove anti-aliasing by flattening your linework to a bitmap when you've finished combining elements, then converting back to RGB or CMYK mode to add your color.

1 Select the portion of your image you want to rotate or change in size (scale) by making it the active layer—in this case, it's the weapon—and choose Free Transform.

2 Use the squares at the corners of the box around your image to drag it larger or smaller (holding down Shift as you do so keeps the image in proportion), or enter a percentage in the Tool Options bar.

3 To rotate a selection, hover the mouse just outside the bounding box until the cursor turns into a curved, two-ended arrow. Dragging to the left or right rotates the whole selection—though you can also enter precise degrees in the Tool Options bar. Why rotate something? Well, it's most useful to inject some life and movement into your shonen strips, especially if you're using the same basic characters from panel to panel. Even a small movement in an arm, leg, or head can change a character's body language in a big way!

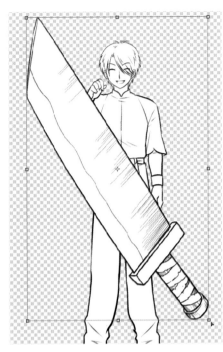

4 When you've finished adjusting your image, press the Enter key or the "tick check" on the right side of the Toolbar.

Flipping (or mirroring) your image is also an ideal way to shake things up a bit! Do this any point by selecting Image > Rotate > Flip Horizontal.

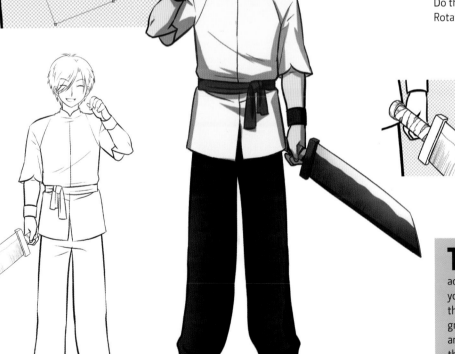

Tip Reducing the Opacity of the accessory layer can help you to position your object. Above, for example, by reducing the Opacity of the knife, you can place the grip in the character's hand and erase those areas of the grip behind the character's thumb, so that he appears to be holding onto it firmly. Don't forget to up the layer to 100% Opacity after you're done!

SHONEN

MIXING COSTUME SETS

There are many ways to vary your characters to perfect the look you want for your shonen story. As well as adding accessories and making alterations to the clothing, you can also borrow elements from other characters. You can do this just as you would add an accessory. Drag or copy the layer you want onto your target image and then use the Free Transform tool to adjust.

Here this young ninja has moved up a belt! The Legs layer from the ninja master character has been transfered to the Male Lead.

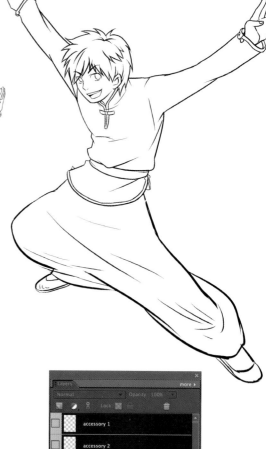

CREATING CLOSE-UPS AND POSES

You're now the ultimate master of combining layers to create characters: now, using the same methods, you can create close-ups and alternative poses for your main characters! As your shonen strip will feature a lot of male leads, supporting characters, antagonists, and outright villains, it's a good idea to change up their poses and looks as much as possible. Help keep your panel-to-panel storytelling interesting, and make each member of your cast stand out! One simple way to create alternative poses is to simply adjust your character's Head layer, so here's how to do it!

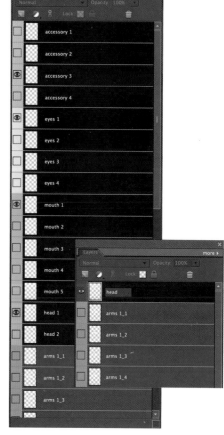

1 Open your character in Photoshop and turn on the layers you want to use for the head, eyes, and mouth, as well as head, face, or hair accessories.

2 Merge the Head, Eyes, Mouth, and Accessory layers (Ctrl/Cmd + E) into one layer.

3 Using the Free Transform tool, rotate your character's head to create different poses, and suggest different states of emotion.

Tip This is an especially handy technique for when you add your main characters to close-up panels. Small changes in the angle of the head or the tilt of the mouth can translate into big differences in emotion! Don't forget, you can draw in your own mouths or eyes using the Pen and Brush tools as well. The possibilities are endless!

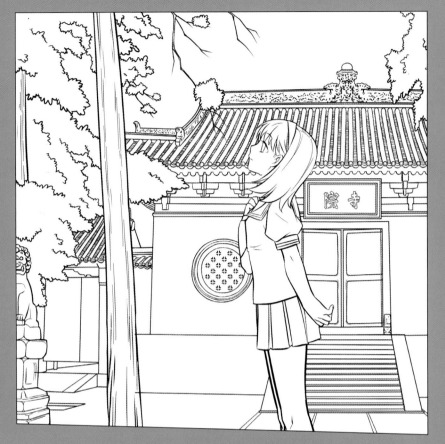

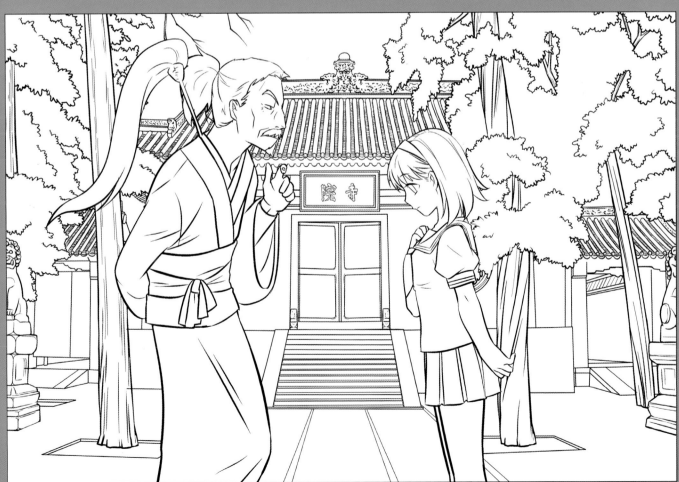

SHONEN
PACING YOUR STORY TELLING

THE ULTIMATE GOAL OF CREATING A SHONEN MANGA IS TO TELL A GOOD STORY CLEARLY, USING A MIX OF WORDS AND PICTURES. WHILE AWESOME DRAWINGS, INCREDIBLE EVENTS, POWERFUL CHARACTERS, AND AMAZING DIALOGUE ARE IMPORTANT—AS ALWAYS—TELLING THE STORY CLEARLY SHOULD BE THE SUMMIT OF YOUR ASPIRATIONS. ARE YOU READY? YES YOU ARE! WHEN CREATING A SHONEN MANGA, YOU'RE THE DIRECTOR OF YOUR OWN ACTION MOVIE, RESPONSIBLE FOR EVERY DECISION. AND YES, ATTRACTIVE LEADS, CRAZY ALIENS, AND A LOT OF EXPLOSIONS ARE ALL VERY IMPORTANT (ESPECIALLY FOR THE MARKETING DEPARTMENT), BUT ONLY THE MOST DEDICATED CINEMA-GOERS ARE GOING TO SIT THROUGH A CLIPS REEL OF THINGS BLOWING UP AND PEOPLE SHOUTING FOR NO REAL REASON. MAKE SURE YOUR STORY FLOWS WELL, MAKES SENSE, AND CONVINCES YOUR AUDIENCE TO FEEL FOR YOUR CHARACTERS.

1 Before you can get elbow-deep into the blood and guts of your story's page-by-page pacing, you need to start with the basics. Whip out a few pieces of scrap paper and start doodling some ideas down. Rummage through your hind-brain for an award-winning story concept. You'll need a setting (is it the present day or the far future? Does your story take place in a high school or a top secret military base?); some characters (what do they look like, talk like, how do they know each other?); and a conflict that will form the catalyst of your story (it doesn't have to be an alien invasion or a zombie attack, although those always go down well—it could just as easily be a new kid proving himself in town via underground BMX-racing, or an Olympic swim-champion battling crime in and out of the pool). Think big, think crazy, think unique! From there, try to work out how long your story could last. Don't be too ambitious at first—you might get frustrated and give up if you plan a thirty-volume masterpiece—start with something achievable to build up your confidence. You could start with a short story set in your chosen world, or even write a first chapter that works as both a standalone tale and the first taste of a larger, ongoing adventure! If you're stuck, read your favorite works of shonen manga again for inspiration (as if you need the excuse!).

2 Once you settle on a story concept, try to write the first few pages as a script. As you'll be putting the pages together yourself, it doesn't need to be too detailed—just a few notes as to what your characters are doing, and where, should be enough for the visual side of things. The most important part of your script is the dialogue, the conversations that your characters will have. Keep it concise and interesting, and remember to split long word balloons over several panels—nobody wants to read three paragraphs of text squashed into one corner of the page! Manga thrives on the interaction between the pictures and words on the page, and nowhere does action speak more clearly than in shonen. Your drawings and pictures from the CD do the heavy lifting in terms of storytelling—the dialogue is there to clarify and entertain. Don't cover up your great-looking pages with endless word balloons.

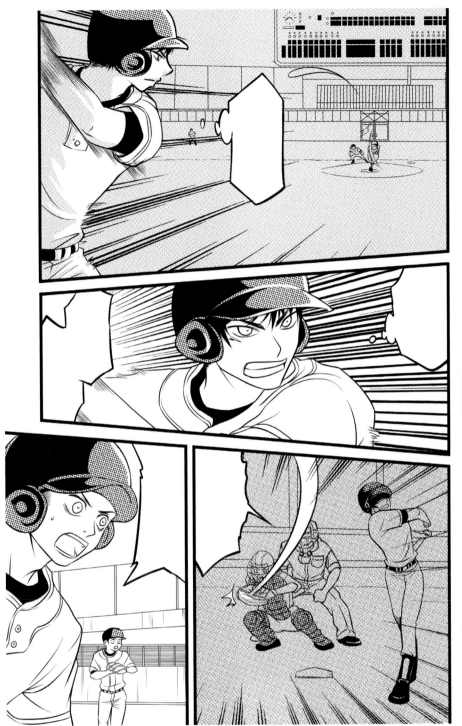

3 Look over the script for the episode you've just written. How many pages will it cover, and how many panels will be on each page? Shonen manga is all about action, action, action, flashing past the reader at a blistering pace! A series of small panels can help "sell" a frenetic single moment, like a character leaping from building to building, while a large panel or full page image can be useful for a dramatic entrance or a world-shaking statement from your lead character. In a standard manga book, you will find most pages have between four and six panels—any more and detailed artwork will become hard to follow. Six to seven panels are possible, of course, but you'll probably not want to go above that—with the exception of small panels for close-ups, or asides from "chibis" (exaggerated, miniature versions of your characters showing extremes of emotion). Give pages that establish new locations fewer panels, so that you can show a new environment (and the characters' relation and reaction to it) in all its glory.

SHONEN

CREATING MANGA PAGES

PREPARE THE PAGE LAYOUT

WHEN YOU'VE CHOSEN YOUR CHARACTERS AND BACKGROUNDS FROM THE DISC AND SAVED THEM APPROPRIATELY, OR HAVE SCANNED IN YOUR HAND-DRAWN IMAGES, THE NEXT STEP IS TO ASSEMBLE THEM INTO A FINISHED PAGE!

1 Decide in which direction you'll be telling the story: left-to-right is Western style, right-to-left gives a story an "authentic" manga feel. Modern manga readers can handle both directions, but remember to let them know the right end of the book at which to start! All our examples in this book use left-to-right.

2 There are numerous page layouts on the CD, ranging from one, two, or three panels per page to seven or more panels per page, all with different combinations, arrangements, and sizes of panels. The pages are set to the dimensions of a standard manga book collection, or tankubon, such as those published by TOKYOPOP. For splash pages, simply use a blank page layout. Choose a panel layout for each page that best reflects the script you've written—but don't be afraid to alter your script if it's not working on the page.

3 There are loads of techniques you can try to add variety to existing layouts. Erase panel lines to make a borderless panel, so that the art or character appears to float in space, or add a small panel within a bigger panel for an extreme close-up. You can also erase panels completely and replace them with outlines more to your own liking, using the Pencil tool. You can draw straight lines with this tool by clicking a start point, then holding the Ctrl key and clicking the end point; Photoshop will draw a straight line between them. Don't forget, you can also flip panels vertically or horizontally using the Free Transform controls.

4 Feel free to experiment, but keep the mantra of "easy to read" at the front of your mind. A Western-style panel layout should be designed to guide the eye from the top left to the bottom right, taking in all the panels in between in the order you want them to be read. Always double-check to make sure that your "panel flow" is clear. If you've done an incredible piece of art or an experimental layout that looks great but doesn't read very clearly, include some subtle arrows to indicate where the reader should be looking next.

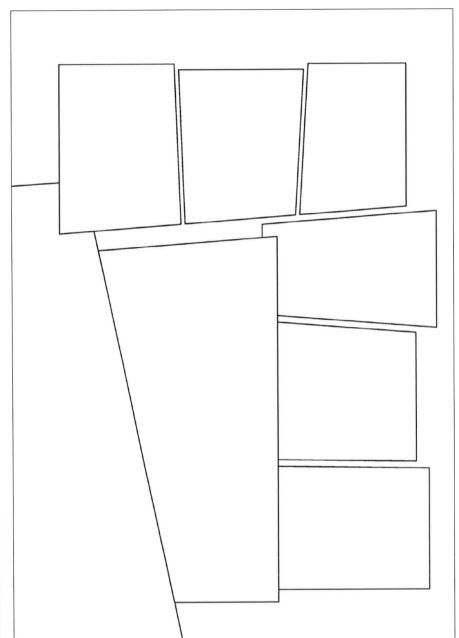

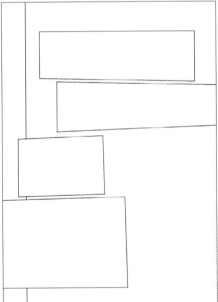

Tip You may find that this alternative method of laying out your pages works better for you. The method we show you on the following pages 30–31 is a "top down" way of assembling your page, choosing your frame, placing the character art first, and then working backwards into the page, before finishing with the dialogue and speech balloons. On the other hand, you may prefer to begin with the dialogue by creating a new text layer, transferring a page of script to speech balloons (see page 44) to make sure it fits your page properly, then designing and laying out your art so that it fits perfectly into the spaces that are left. This will ensure you never place a balloon over an important piece of artwork or character. Photoshop allows you to move and edit layers after they are complete, so you can turn your balloons on and off and move them to better fit the artwork as appropriate. You may also prefer to drop your backgrounds onto the page first, and then place the characters on top, if only to save you a lot of time with the Eraser! To make the white of your characters opaque so that the backgrounds don't show through, flatten your character template, choose the Magic Wand tool, switch Contiguous on, and select the white background around the character. With the background selected, Invert the selection (Ctrl/Cmd + Shift + I), which will leave just your character. Now just copy and paste (or drag) your character onto your manga page. Now you'll only have to delete parts of the character that overlap panel boundaries, rather than erase any parts of a background that show through.

SHONEN

PUTTING THE IMAGES ONTO THE PAGE

1 The next step is to start inserting your characters. Open the first file you have saved containing a character you've made—once it's open, you can just drag the image from the Layers palette onto your manga page. Alternatively, using one of the Marquee tools, select the part of the character you want to use, then drag it across with the Move arrow. You may only wish to drag across a hand or a face if the panel is an extreme close-up. If your character is still saved as separate layers, this can be done by just selecting the layers you want to use and dragging them across, as before.

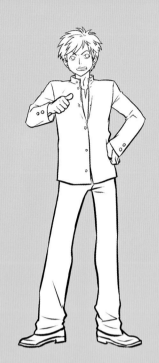

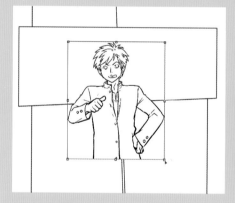

2 Use the Move tool to position the character where you want it, then use the Eraser tool to clean up any parts that fall outside of the panel. If the panel is a regular shape you can speed up this process by using one of the selection tools (Rectangular or Freehand Marquee) to select pieces that overlap the edges, and then deleting them.

3 Repeat the previous steps to transport all of your heroes onto the page.

4 A reader is going to get bored quickly if all of the panels look the same. If you're importing too many characters at the same angle or size, make sure you break out the Free Transform functions. Flip, scale, and rotate your characters from panel to panel to keep things interesting, always remembering that you can edit the images from the CD with the Pencil tool if you want a unique expression or movement. Don't forget to leave some "dead space" in every panel for your word balloons—obviously, the less text you have the more space you can fill with explosive action, though loud sound effects take up room, too.

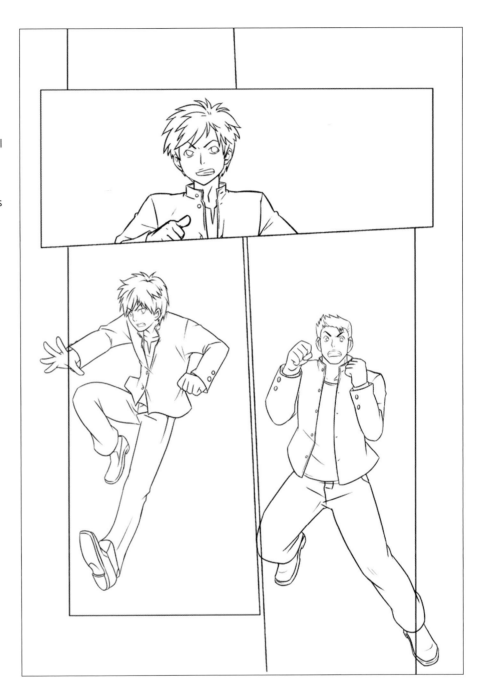

SHONEN

5 Once your characters are in place, it's time to paste in the backgrounds. Backgrounds are often seen as boring and time-consuming by those new to manga—and the latter is often true—but it's well worth quelling your urges to do without them and tackle them straight away! A background-less page quickly leaves readers confused, while a well-rendered background can drop jaws and add wonders to your storytelling. Readers need a cue to the setting in order to understand the story, and your characters need backgrounds to interact with to give them weight and realism. If you have an "establishing" panel (the first time a new location is shown), then it will normally be relatively big, with a wide shot of the scene, and you can directly paste in one of the provided backgrounds. For the other panels, you'll need to chop, flip, and scale the background images in order to make them fit. Remember that if you just show small snippets of a single background image across the backgrounds of multiple panels, you can make one image go a long way!

6 Once again, use the Eraser or selection tools to clear any areas that overlap panel borders.

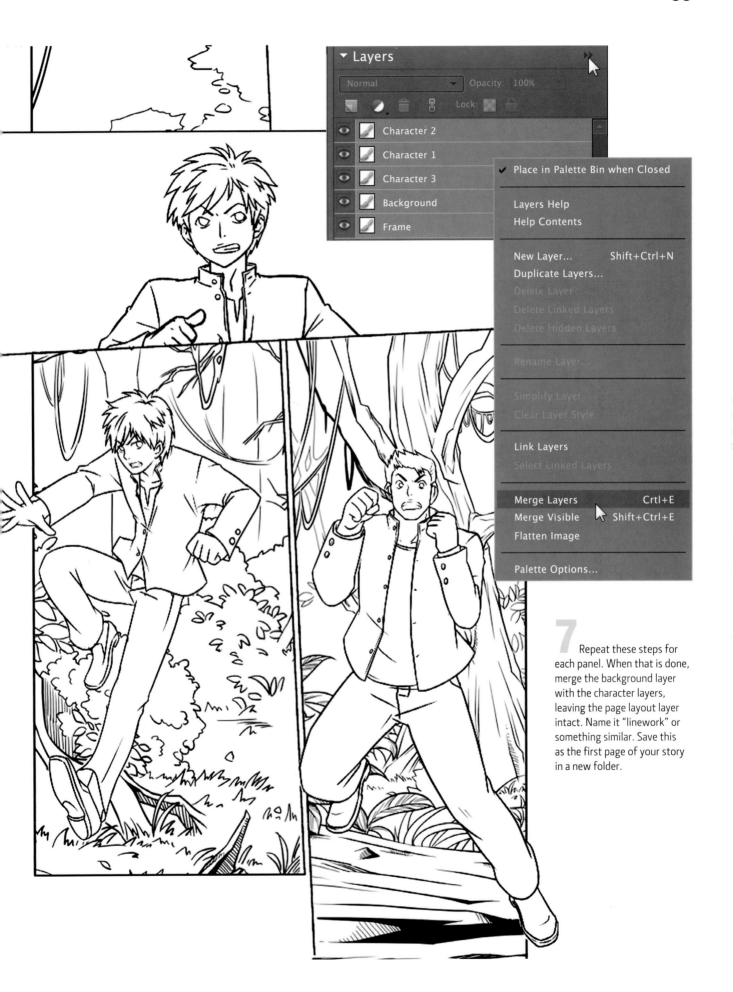

Layers

Normal ▾ Opacity: 100%

Lock:

●	Character 2
●	Character 1
●	Character 3
●	Background
●	Frame

✓ Place in Palette Bin when Closed

Layers Help
Help Contents

New Layer... Shift+Ctrl+N
Duplicate Layers...
Delete Layer
Delete Linked Layers
Delete Hidden Layers

Rename Layer...

Simplify Layer
Clear Layer Style

Link Layers
Select Linked Layers

Merge Layers Crtl+E
Merge Visible Shift+Ctrl+E
Flatten Image

Palette Options...

7 Repeat these steps for each panel. When that is done, merge the background layer with the character layers, leaving the page layout layer intact. Name it "linework" or something similar. Save this as the first page of your story in a new folder.

HOW TO CONVERT A PHOTO INTO A BACKGROUND

THERE ARE TEN GREAT BACKGROUNDS INCLUDED ON THE CD, BUT THAT SELECTION MAY NOT LAST YOU TOO LONG, AS YOU FEVERISHLY BURN THROUGH YOUR FIRST STORY! YOU'LL NEED MORE TO KEEP YOUR STORIES LOOKING AND FEELING FRESH. HEWING YOUR OWN ARCHITECTURE FROM THE RAW MATERIAL OF A BLANK PAGE IS TOUGH GOING, BUT THERE IS ANOTHER WAY! GRAB YOUR CAMERA AND GET SNAPPING, OR MAKE THE MOST OF YOUR EXISTING PHOTOS. HERE ARE TWO EASY METHODS TO SHOW YOU HOW TO CONVERT TREASURED SNAPS INTO SHONEN SCENES.

METHOD ONE:

1 Scan a photo, or import one from a digital camera, and open it in Photoshop or Elements. For our purposes, the bigger the photo is, and the higher the resolution, the better.

2 Change the photo into grayscale (Image > Mode > Grayscale).

3 Duplicate the layer. This keeps your original image for reference at the bottom of the Layers palette, which can be useful if you need to check details or even start the process again.

4 Click Filter > Adjustments > Threshold (or Image > Adjustments > Threshold in Photoshop). An option window will appear. Slide the bar inside it—try to find a position on the slider that best approximates line-art. For this particular photograph, a Threshold of 108 produces the optimum result.

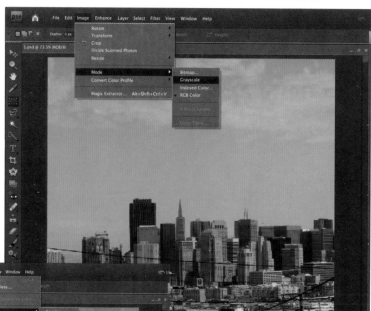

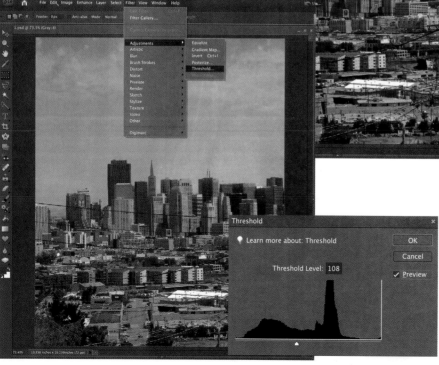

5 Set the layer's Blending mode to Multiply. This will reveal the original photo underneath—you may want to alter the Opacity of your converted image. Compared to the original, you can see a lot of detail has been lost in the convertion process. Click over to the Pencil tool, and use black and white colors to add back in any essential bits of detail and clean up any areas that look too messy.

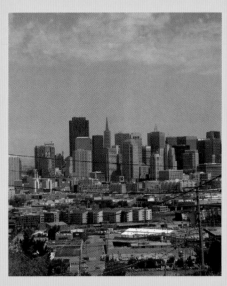

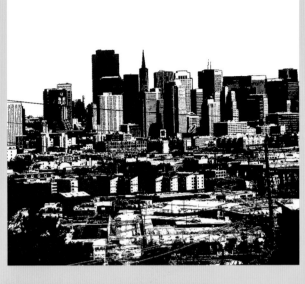

6 Turn Multiply off, merge the layers, and your background is ready to use!

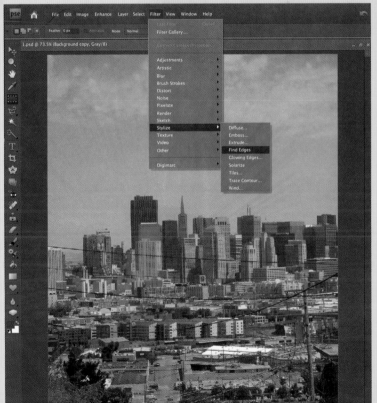

METHOD TWO:

1 Follow steps 1–3, as above.

2 Click Filter > Stylize > Find Edges. The photo is converted into line-art.

3 This method keeps a lot more detail than the first, but the finished result is visibly messier. Just like in the first method, use the Pencil tool to get a handle on the level of detail. Adjust and redraw until you're happy, then merge the layers as before.

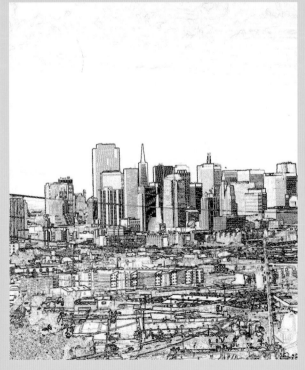

Tip There are many different filters in Photoshop, and plenty of them will help you transform your photos into perfect background material. Don't be afraid to experiment: be bold with your choices! Adjusting the Levels (Image> Adjustments > Levels) of a raw grayscale photograph may give you cleaner results.

36 SHONEN

ADDING SPEEDLINES AND FOCUS LINES

DEFINITION TIME! SPEEDLINES ARE TIGHTLY PACKED, NEAR-PARALLEL LINES THAT SHOW DRAMATIC MOVEMENT, WHILE FOCUS LINES ARE A GROUP OF LINES THAT RADIATE OUT FROM—AND DRAW ATTENTION TO—A FOCAL POINT. IF YOU'VE EVER READ A SHONEN ACTION SCENE OR TENSE MOMENT (AND WE'RE BETTING YOU'VE READ MORE THAN YOUR SHARE), YOU'LL KNOW THAT THESE TECHNIQUES ADD A REAL PUNCH TO . . . WELL, PUNCHES—BUT ALSO MOTORCYCLE CHASES, PLUMMETING AEROPLANES, ARROWHEADS IN FLIGHT, FALLS FROM IMPOSSIBLY-TALL TOWERS, AND MORE. THANKS TO THE EXAMPLES ON THE DISC, IT'S NEVER BEEN EASIER TO ADD DEPTH AND VARIETY TO YOUR PANELS AND ADD BLISTERING EXCITEMENT TO YOUR ACTION SCENES. DON'T FORGET THAT THEY CROP UP IN QUIETER SCENES, TOO, WHERE THEY EXPRESS STRONG FEELINGS, SUCH AS SHOCK, RAGE, OR DEPRESSION. FOR ACTION SEQUENCES, IMAGINE SPEEDLINES AS THE WIND THE MOVEMENT OF A CHARACTER CREATES, OR AS LINES TRACKING THEIR PROGRESSION THROUGH SPACE. THESE LINES CAN BE STRAIGHT OR CURVED. FOCUS LINES, ON THE OTHER HAND, ARE MOST OFTEN USED TO HIGHLIGHT TENSION OR A SUDDEN SHOCK. THE MORE DENSE THE FOCUS LINES ARE, THE TENSER THE SITUATION!

FOCUS LINES

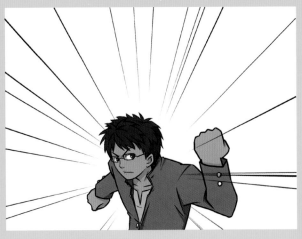

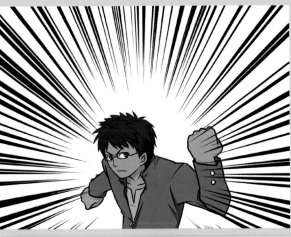

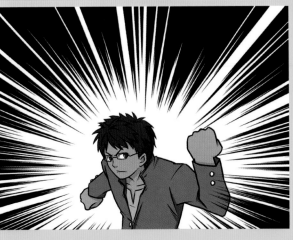

SPEEDLINES

HOW TO ADD SPEED
AND FOCUS LINES

1 Pick one speed or focus line image from the CD.

2 You probably won't need to paste the whole image into your panel. Instead, use the rectangular selection tool to select part of the lines (most likely the central area) and paste it into the panel.

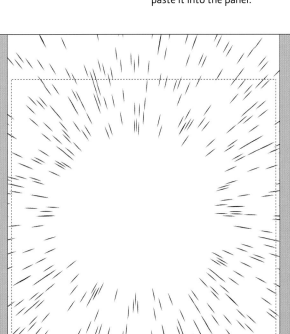

3 Use Free Transform to adjust the shape to fit in your panel.

4 Using the Eraser tool on the line layer, clean away any parts you don't want. Speed and focus lines can partially overlap with backgrounds and characters, so long as the character at their center remains largely unobscured. Don't forget that you can add color or tone to your lines, too, or adjust their Opacity for interesting effects!

38

SHONEN

ADDING TONE TO PAGES

WHILE WESTERN COMICS ARE NORMALLY COLORED, THE VAST MAJORITY OF MANGA—BOTH SHONEN AND OTHERWISE—ARE IN BLACK AND WHITE. THIS COULD CREATE A PROBLEM WHEN SUGGESTING SHADOWS, LIGHT, DEPTH, AND MOOD. THANKFULLY, TONING SOLVES THAT PROBLEM WITH STYLE! THOUGH MADE UP OF TINY, REPEATED DOT PATTERNS, TONING CAN QUICKLY ADD "COLOR," TEXTURE, AND DEPTH TO YOUR BLACK AND WHITE MANGA PAGE. IN THE PRE-DIGITAL DAYS (AND FOR TRADITIONALISTS), LETRATONE SHEETS WERE USED, LAYERING AN INSTANT PATCH OF GRAY TONE OVER INKED ARTWORK, EFFICIENTLY CONJURING SHADOWS AND TEXTURES. THESE SHEETS WERE EITHER

RUBBED DOWN AS TRANSFERS, OR CUT OUT AND STUCK ONTO ORIGINAL PAGES. THESE DAYS, MANGA ARTISTS IN THE WEST MOSTLY USE DIGITAL TONES INSTEAD. IT IS CHEAPER, QUICKER, HAS MORE VARIETY, AND IS A LOT SIMPLER TO UNDO IF ANYTHING GOES WRONG! TONING IS AN ART IN ITSELF. SOME ARTISTS USE A WIDE VARIETY OF DIFFERENT TONES FOR A LUXURIOUS FEEL, WHILE OTHERS STICK TO ONE OR TWO SIMPLE TONES TO KEEP THE PAGE NEAT AND THE STORYTELLING PARAMOUNT— NOT TO MENTION THEIR DEADLINES ACHIEVABLE!

THERE ARE TWO METHODS OF TONING YOUR PAGE WITH THE TONES SUPPLIED ON THE CD.

METHOD ONE:

1 Select the tone you want to use and open it in Photoshop.

2 Estimate the size of the area you want to tone, then select an area of your tone that is slightly bigger. With the selection tool, drag your selection onto your shonen page.

3 Using the Move tool, place the tone where you want.

4 Tidy up the area using the Eraser tool.

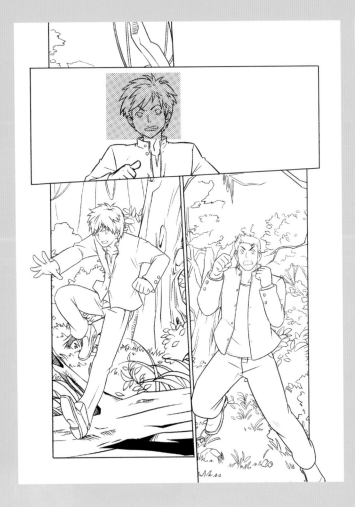

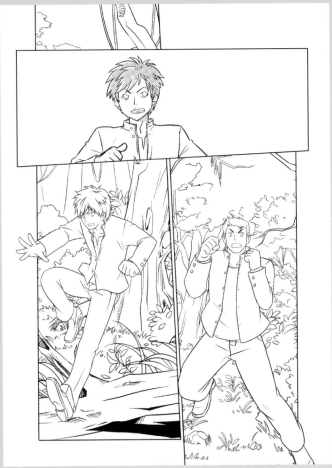

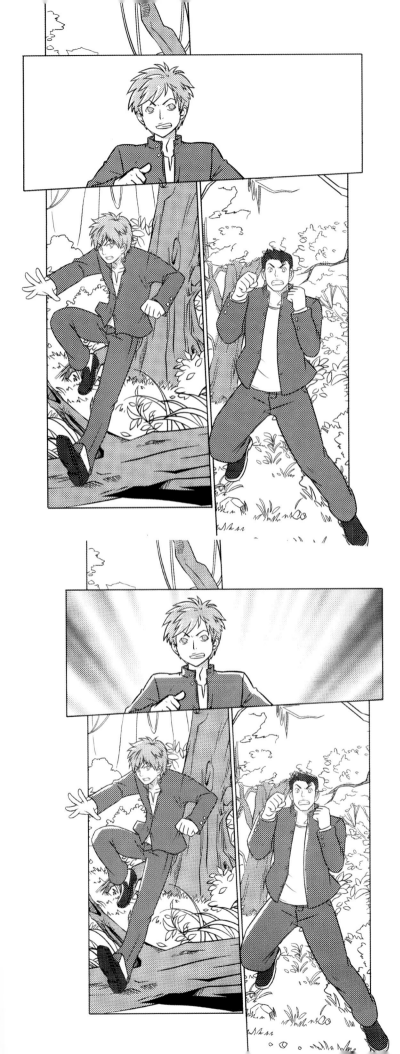

5 Repeat the above steps to add as many tones as you like. Don't overlap dotted tones if at all possible, because this is likely to create unintentional moiré patterns in print—this is where two tones "compete" with each other on the page and look fuzzy to a reader's eyes.

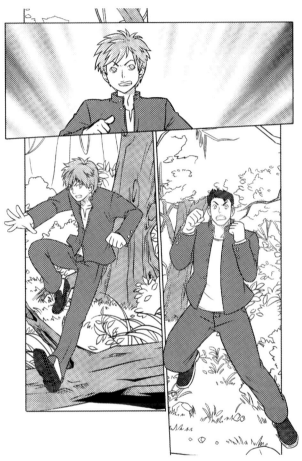

6 The Eraser tool is great for removing the areas of tone you don't want, but it's even better for adding highlights. Erase thin lines or circular points to give definition.

SHONEN

METHOD TWO:

1 Open the tone image you want to use, and select the Clone Stamp tool. Alt + click any area on the tone image. An area in the middle will give you the most flexibility when painting with the tone.

2 Use the Clone Stamp tool to draw directly onto the page. For best results, always do this on a new layer set to Multiply.

3 Use the Eraser to remove any areas of tone you don't want, and to add highlights where appropriate.

4 Repeat as required until your page is fully toned.

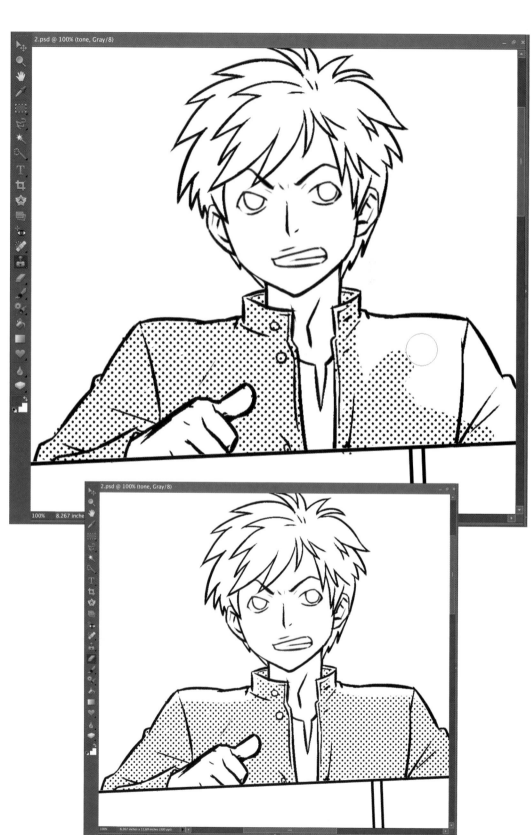

Tip If there are some tones you use a lot, you'll want to set them as patterns in Photoshop. To do this, first select the pattern you want on the tone image, then click Edit > Define Pattern, and name the pattern something memorable. When you need to use this tone again, just select the Pattern Stamp tool. A pattern box will appear in the Toolbar Options along the top of the screen with all the patterns you have defined. Select the pattern you want to tone with and paint directly onto the manga page.

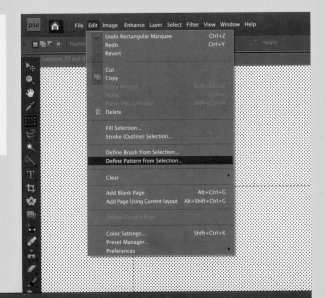

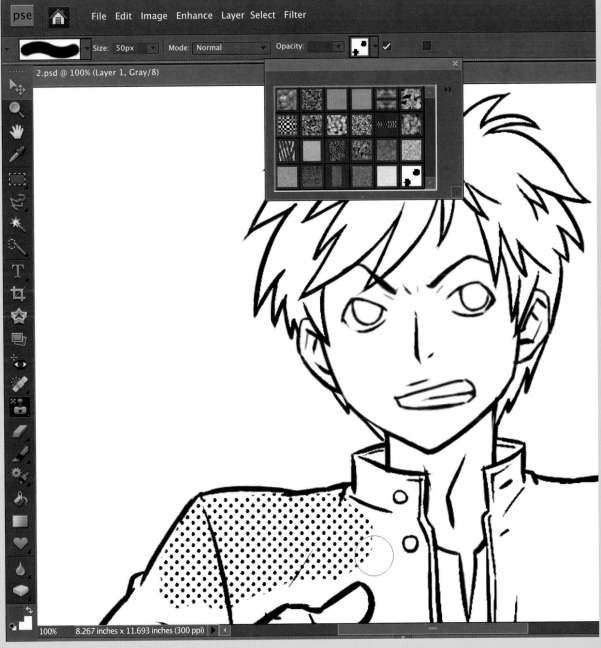

CREATING YOUR OWN TONES

THOUGH WE HAVE SUPPLIED A WIDE RANGE OF TONES, IT'S LIKELY—IF NOT INEVITABLE—THAT YOU'LL WANT TO GENERATE YOUR OWN UNIQUE DESIGNS AT SOME POINT. THE FOLLOWING STEPS WILL HELP YOU DO JUST THAT!

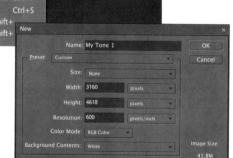

1 Create a new document at the same dpi (600 dpi) and page dimensions (3160 x 4618 pixels) as the manga page file. You can name it however you like, though a descriptive name like "mytone_01.psd" will help you keep track.

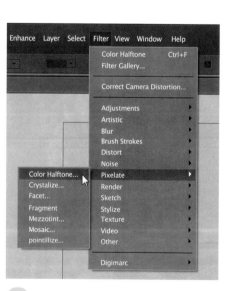

2 Fill the entire page with light gray.

a) If you are using Photoshop, go to Images > Mode > Bitmap. Bitmap is a file format that only supports black and white. By converting the light gray to Bitmap, we can transform it into the familiar black dots.

b) In Photoshop Elements you can achieve a similar effect using filters. Go to Filter > Pixelate > Color Halftone.

3 a) After you select Bitmap mode, an option window will pop up. Change Method to "Halftone screen." In the next pop-up window, set Frequency at 32 lines/inch, the Angle to 45°, and select a shape. Round is the most common, but you can, of course, try the others! Create different tones by playing around with the various options in this menu.

b) Choose a Maximum Radius and experiment with the Channel settings to find a pattern you like.

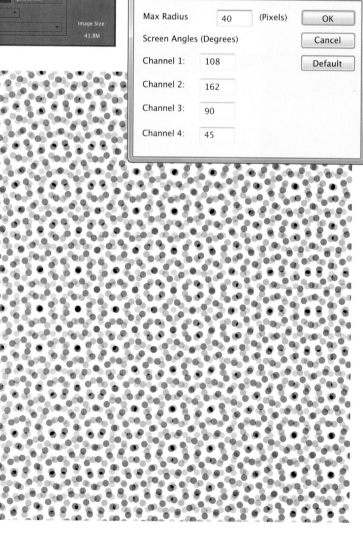

4 Convert the file back to Grayscale (Images > Mode > Grayscale), and in Photoshop, set the ratio to 1 in the pop-up option window. Your brand-new tone is ready to use.

Tip The toning madness doesn't stop there! You can create personalized tones from textures, fabrics, and objects all around you, such as camouflage, woodgrain, reflective metal. . . Anything and everything has the potential to be a great tone. Just scan your chosen texture or image in at the same dpi as your manga page file, convert it to Grayscale, adjust the brightness/contrast settings so the pattern is clear, and then convert it to Bitmap as above, or use the Color Halftone filter in Elements. Be prepared to experiment with different settings before you stumble across one that gives you a great result, but just continue to adjust the brightness/contrast settings until you are happy. Don't forget to try out different filters before converting the image to Bitmap, as you can create some awesome patterns this way!

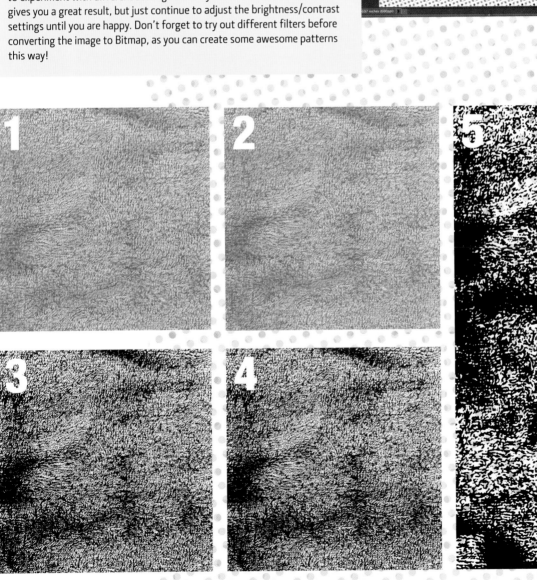

LETTERING: TEXT AND WORD BALLOONS

THIS IS THE STAGE WHERE YOU FINALLY GET TO TRANSFER YOUR WITTICISMS, BOLD STATEMENTS, FRANTIC SHOUTS, AND BLOOD-CURDLING SCREAMS ONTO THE PAGE! THE IMPORTANCE OF THE LETTERING STAGE IS OFTEN OVERLOOKED IN THE CREATION OF MANGA, BUT IT'S ONE OF THE MOST ESSENTIAL PARTS. YOUR READERS RELY ON DIALOGUE BALLOONS TO GUIDE THEM THROUGH EACH PAGE—AND TO TELL THEM THE STORY.

THE FLOW OF YOUR WORD BALLOONS AFFECTS THE WAY PEOPLE READ THE STORY (IDEALLY YOU WANT THAT FLOW TO BE SO SMOOTH AS TO BE INVISIBLE!), WHILE THE FONTS YOU CHOOSE FOR YOUR CHARACTERS' SPEECH (AND ANY SOUND EFFECTS) AFFECT NOT ONLY THE LOOK OF YOUR PAGE, BUT ITS MOOD. WITH A MINIMUM OF 60,000 FONTS IN EXISTENCE, YOU'VE GOT PLENTY TO CHOOSE FROM. MANY FONTS ARE ONLY AVAILABLE FOR A FEE—SOME ARE QUITE EXPENSIVE—BUT THERE ARE MANY WEBSITES THAT ALLOW YOU TO DOWNLOAD GREAT FONTS FOR FREE. FOR A WIDE RANGE OF GENERAL FONTS (GREAT FOR LOGOS AND SOUND EFFECTS), CHECK OUT 1001FONTS.COM OR DAFONT.COM, WHILE BLAMBOT.COM PROVIDES A NUMBER

OF FREE FONTS THAT ARE PERFECT FOR DIALOGUE: CHECK OUT LETTER-O-MATIC, ANIME ACE, AND WEBLETTERERBB IN PARTICULAR. MAKE SURE THAT ANY FONT YOU CHOOSE IS LEGIBLE, AND EASY TO READ. CURSIVE AND EXOTIC FONTS ARE A NO-NO, AS THERE'S NO BETTER WAY TO ANNOY AND LOSE A READER THAN TO MAKE THEM WORK AT READING A PAGE. COMIC SANS IS UNPOPULAR AMONG THE PROFESSIONAL COMICS COMMUNITY, BUT IF YOU DON'T HAVE AN INTERNET CONNECTION, IT IS TECHNICALLY A ROUGH APPROXIMATION OF A COMICS FONT, AND COMES INSTALLED ON EVERY COMPUTER. USE IT IF YOU MUST, JUST UPGRADE FROM IT ASAP!

1 To get started, choose a font from the drop-down list at the top left of the Tool Options bar that you think will be suitable for the story. For most shonen, you'll want something bouncy, unobtrusive, and easy-to-read—your sound effects should draw attention to themselves, but let your dialogue be submissive to the art. Here, a free font that comes with most standard Windows systems is used and the size set to 7 pt. You can adjust the font size depending on the font, the size of the page, whether it's for print or for the web, and whether your character is whispering or shouting. The point size is flexible, as long as it's legible.

2 Select the Text tool (press T). Copy the dialogue for one balloon from your script and paste it (Ctrl /Cmd + V) on the page where you want it to go, or type it directly onto your page. Make sure your text is in capital letters: sentence case letters often leave dangling "tails" from letters like "j" and "y," which get entangled in the type below them. Aside from looking messy, your balloons will end up very hard to read, with lots of criss-crossing lettering. When your text is capitalized, center it (Ctrl/Cmd + Shift + C) and use the Return key to arrange it into a relatively round (or elliptical) shape so it can fit neatly into a word balloon.

3 Make sure the text is not too big or too small for the page. To adjust its size, click into the Character palette or grab the Free Transform tool. Holding down Shift as you drag the Free Transform points will keep all the letters in proportion. Don't forget to add any emphasis at this stage—putting words in bold and italics draws attention to them and adds character to your dialogue, making it easier for the reader to hear your words in their head. Think about where you place emphasis in a sentence when you say it aloud, and bold or italicise that word—or use the same method to draw attention to the most important part of a sentence. "This bomb is about to *explode*!," for example. Think of all the subtle ways you can control meaning in even the most obvious sentence— such as the difference between "I'm going to *kill* you!" and "I'm going to kill *you*!"

4 Check that all your lettering sits inside the page frame—if you end up printing the page in a book, you may find that items outside the frame are cut, or "trimmed." This doesn't matter so much if you are publishing only on the web, but it's good to remember that even if your artwork overlaps the edges (or "bleeds" over the edge), your lettering must always stay within it.

Tip In Photoshop, clicking Window > Character makes the character palette pop up. This gives you access to a selection of tools and further options that give you greater control over your type, all packed into a convenient space. Here's just one time-saving tip: select your text and click on the small triangle at the top right of the Text palette (above the selections for Regular, Bold, etc.); here you can change your selection into All Caps—useful if your script is in regular sentence case.

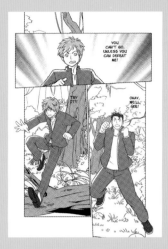 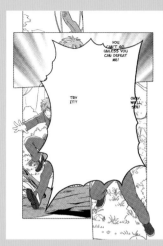

5 Find a balloon shape you like on the CD. In manga, there are different types of balloons for dialogue, shouting, thoughts, and captions (boxes that introduce new scenes, or add third-person narration). Select one that is suitable for your text and drag it to the manga page, moving it onto a layer just beneath the text. Scale and flip the balloon to best fit, making sure to leave enough "breathing room" around the dialogue so that it isn't too cramped. You'll find that a whispering character will have a lot of empty balloon space around a smaller dialogue font. Double-check that the tail of the balloon points to the person talking!

6 Adjust the text and balloon to best show off the artwork and ensure that the panel and page flow correctly. Remember that if someone is the first to speak in a panel, they and their balloon should be on the left-hand side. If you've placed them on the right in your artwork, it's not the end of the world, just place the right-hand balloon above the one on the left, to drive home which balloon should be read first. Make sure the balloons don't cover up anything you're particularly proud of, or that's essential to the plot.

7 Repeat the above steps to transfer all your text into balloons on the page. When you're done, read over the page again to see if there are any points in your script that now seem unclear when your words and art are combined. Is there anything you can clear up by adding another small balloon or sound effect anywhere? Or are there balloons or lines of dialogue that can be safely removed? If a character is saying, "Look, there's Death Mountain!" and they're in a panel pointing at a sign that says, "Death Mountain, Right Ahead," you can probably drop the redundant dialogue. . .

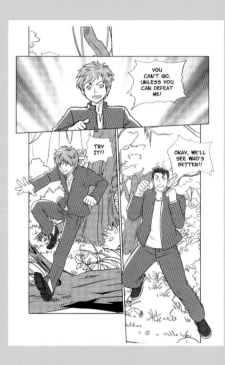

CREATING YOUR OWN BALLOONS

As with characters and tones, you'll want to experiment with your own balloon designs at some point. Here's a quick and easy method so you can dive right in!

1 Type your text onto a new layer, as above, and create another new layer underneath your dialogue.

2 Using the Elliptical Marquee tool, draw a balloon shape around the text, making sure you leave "breathing space" around the dialogue on all sides.

3 Holding down the Shift key, so you can add to your selection, use the Freehand Lasso tool to draw a tail pointing to the mouth of your character.

4 Use the Paint Bucket tool on the balloon layer to fill the selection with black. Choose Select > Modify > Contract and set the contraction to between 2 and 6 pixels.

5 Now fill the selection with white, and there's your balloon! Other shapes can be drawn freehand with the lasso—experiment with the jagged screams, serene thoughts, and frazzled shouts you can conjure with your mouse!

SHONEN
ADDING SOUND EFFECTS

SOUND EFFECTS ADD DEPTH, FLAVOR, AND INTEREST TO A MANGA PAGE, AND NO MANGA LOVES AN AWESOME SOUND EFFECT MORE THAN A SHONEN STORY! FROM AN EXHAUSTED SIGH AT YET ANOTHER CHORE, TO THE PLASMIC DISCHARGE OF THE ULTIMATE PSIONIC ENERGY BLAST, SOUND EFFECTS SERVE TO DRAW YOUR READERS DEEPER INTO THE ACTION, AS WELL AS PROVIDING THE PULSE OF ANY ACTION SEQUENCE. WHILE YOU DON'T NEED TO DOCUMENT EVERY SINGLE SOUND MADE OVER THE COURSE OF YOUR STORY, YOU CAN USE THEM TO DRAW ATTENTION TO THE MOST IMPORTANT PART OF A SCENE. A SPY'S SQUEAKING SHOE GIVES THEM AWAY IN A TENSE STAKEOUT, WHILE THE TEARING SOUND OF A RIPCORD SUGGESTS THAT A PARACHUTING SOLDIER IS GOING TO BE FLATTER AND WIDER THAN HE'S USED TO IN A MATTER OF MINUTES!

SOUND EFFECTS ARE NORMALLY APPLIED DIRECTLY ONTO THE PAGE—THEY DON'T GO INTO BALLOONS—AND OFFER A LOT OF OPPORTUNITIES FOR INDIVIDUAL EXPRESSION AND FUN TECHNIQUES. SOUND EFFECTS ARE SCALED IN RELATION TO THE LOUDNESS OF A SOUND: A GUST OF WIND WOULD USE SMALL AND DELICATE LETTERS, WHILE THE RETORT OF A SUBMACHINE GUN MIGHT TAKE UP ALL THE SPACE IN A PANEL NOT FILLED WITH ARTWORK. CHOOSE A FONT THAT FITS THE SOUND, TOO: A ROUGH AND CHUNKY FONT WOULD BE APPROPRIATE FOR AN EXPLOSION, WHILE THE LETTERING FROM A RETRO CALCULATOR WOULD BE PERFECT FOR AN ELECTRONIC BEEP. PHOTOSHOP AND PHOTOSHOP ELEMENTS BOTH ALLOW YOU TO WARP TEXT, USING THE CREATE WARPED TEXT OPTION IN THE TEXT OPTIONS TOOLBAR, WHICH IS PERFECT FOR CREATING ALL KINDS OF SOUND EFFECTS OR INNER DIALOGUES.

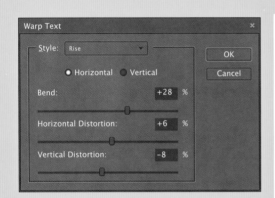

Don't forget, too, that you can scale, rotate, chop, and otherwise rearrange your lettering. To do this you will first need to rasterize the lettering (Layer > Rasterize > Type) or simplify in Elements (Layer > Simplify Layer), which changes it from editable type into flat imagery. Make sure you have spelled everything correctly before doing so! You might also want to make sure the letters have no aliasing effects applied to them—choose "None" rather than "Sharp" or "Smooth" so that you can color or apply gradient effects to the text afterwards. Once rasterized, the text behaves like any other part of the image—you can alter it using the Free Transform tools.

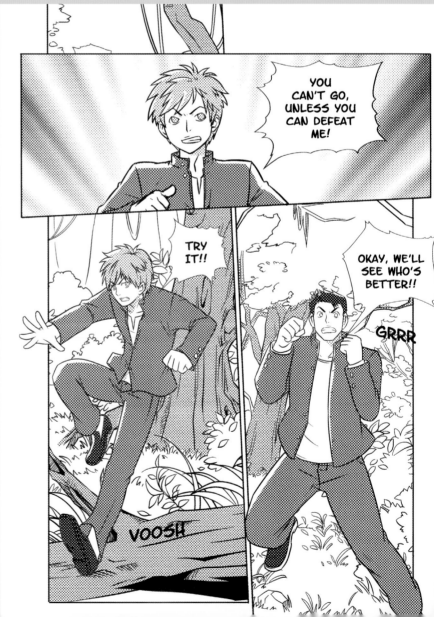

You may also wish to add a border around the letters to make them stand out from the background more. Select the letters of your sound effect with the Magic Wand, or select the whole word with the selection tool, flip to the Move tool, and hit any arrow key to clamp the selection tight around the letters. Now go to Select > Modify > Expand. The number of pixels to expand by will depend on the size of your sound effect: start with 10–15 and scale up accordingly. Use the Paint Bucket (with Contiguous unchecked) to fill the expanded selection with another color. Then go to Select > Modify > Contract to create a smaller selection, and fill with white (as you did for steps 4 and 5 for Creating Your Own Balloons), giving your letters a punchy color border. It's best to do this stage before scaling or rotating your rasterized sound effect, as any Transformation of the image anti-aliases it and makes it difficult to fill.

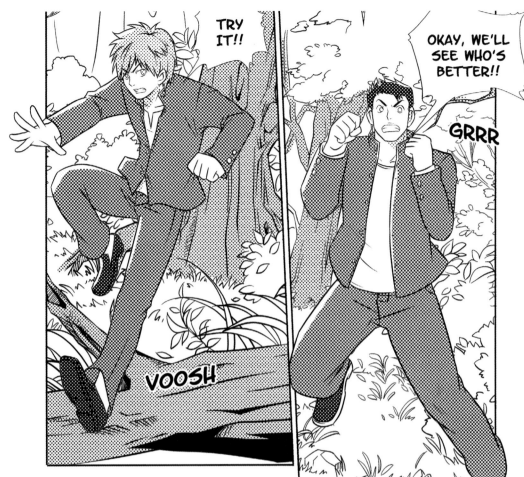

Here are some examples of sound effects used in manga—creating new sound effects is endlessly rewarding and fun!

LAUGHS:
HAHAHAHAA, HUH HUH HUH, HEEE HEE HEEE, HEH HEH HEEEH, HMM HMM HMM

SCREAMS:
AHHH, AIIIEIEEEE, AGGRH, AAAAAAHHHH, AYAAA, EEEYAA, GYEEE, HYAAA, NYAAAAAHHH, UAAAA, YAAAH, YEEEE

IMPACTS, PUNCHES, AND HITS:
BLAM, BANG, BOOM, BONG, BOFF, BOP, BLASH, CHOOM, CHAKKA, CRUNCH, CRASH, DOOM, GLOMP, JACK, KRUNCH, KLONK, KONK, KANG, KRESH, KRUNCK, PAK, PLOK, PING, POW, PWOP, SPLACH, SLAM, SHOOM, SMACK, SMASH, THUD, TUK, THOMP, THOK, TUFF, TOK, WHUMP, WHOK, WHOMP, WONK, WHOOP

GUNFIRE/MAGIC IMPACTS:
BLAM, BRAKKA-BRAKKA, KRA-KOOM, TSSSCHHHHAAA, TRLL TRLL TRLL, CHK-CHKK, FWOOOOM, KRAKOW, TAKKA-TAKKA, SHHHHTOWWWW, THWAMMM

OTHER SOUNDS:
(Can you work out what they may represent?) BEEP, BZZBZZ, CLINK-CLANK, EHH, GRRR, GULP, GEEZ, HUFF-HUFF, PSST-PSST, RING-RING, SIGH, TINK, TING, THBBBTTTPT, VAROOM, VOOSH, ZOAAM

SHONEN
CHOOSING COLORS

NO MATTER HOW AWE-INSPIRING YOUR LINE-ART, YOU CAN RUIN IT WITH THE WRONG CHOICE OF COLORS. WELL THOUGHT-OUT COLOR SCHEMES ARE THE KEY TO PROFESSIONAL-LOOKING MANGA, BECAUSE THEY CONTROL AND INFLUENCE COMPOSITION, DESIGN, AND MOOD. DON'T JUST JUMP INTO YOUR PAGE WITH PAINTBRUSH AND PAINT BUCKET BLAZING, TAKE SOME TIME TO THINK THROUGH YOUR DESIGNS AND LOOK AT SOME OTHER MANGA AND COMICS FOR INSPIRATION. ONE OF THE FIRST CHOICES IS WHETHER TO GO DOWN THE ROUTE OF REALISM AND BELIEVABILITY, OR TO FIND A UNIQUE—IF OUTLANDISH—COLOR SCHEME THAT YOU CAN USE THROUGHOUT. "REALISM" MEANS SOMETHING DIFFERENT IN MANGA, OF COURSE—PINK HAIR AND SWORDS LARGER THAN THE BEARER'S BODY ARE PERFECTLY NATURAL OCCURRENCES . . . THE DIFFERENCE HERE IS BETWEEN COLORS THAT REPLICATE WHAT YOU CAN SEE OUTSIDE YOUR WINDOW, AND COLORS THAT "RING TRUE." YOU CAN HAVE RED GRASS AND AN ORANGE SKY AS LONG AS THE COLORS COMPLEMENT ONE ANOTHER AND CONSPIRE TO JAW-DROPPING EFFECT. NO MATTER HOW RADICAL (OR HOW REALISTIC) YOUR TASTES, IT'S ALWAYS HELPFUL TO GET A GROUNDING IN COLOR THEORY: CERTAIN COLORS WILL NATURALLY COMPLEMENT OTHERS, AND USING THESE TOGETHER WILL TAKE YOUR COLORING TO THE NEXT LEVEL!

THE THREE GOLDEN RULES OF COLORING

RESEARCH
If you are attempting to create a realistic piece, be sure that your colors suit the genre or timescale of your image. If your piece is a historical one, consider the common color schemes of the era. Grab some reference books and go to town.

DESIGN
Include color scheme designs whenever you put a character together, and try to find some kind of consistency and uniqueness in your compositions. Whether it's a ninja in a bright orange jumpsuit or a monster trainer in blue, red, and white, you'll find that the most popular shonen characters have distinctive color looks, as well as unique silhouettes—they work equally well in both color and black and white! Consistency, even in the craziest color scheme, can add professionalism to an image.

HAVE FUN!
What you see here are just the theories and starting points to help you in your color-capturing adventure. Experiment, experiment, experiment to find your own style—and remember that coloring is a long process, even with digital tools, but very rewarding, for all its frustrations!

Colors can evoke emotions and shape thought, on both a conscious and unconscious level. Mixing red, white, and blue in a panel or page—even when not in the shape of a flag—can subtly suggest American, British, or French nationality. The colors in your piece shape the mood of the reader, just as they reflect the moods of the character. Fiery oranges and glowing yellows are hot colors: warmth, passion, even danger, daylight, or the fireside. Blistering reds go further, calling to mind warning signs, insalubrious neon lighting, blood spatters in mysterious rooms, and glowing, demonic eyes hovering in the dark. Blue, green, and purple are cool colors. Their ties to nature—the sea, sky, and land—can be soothing, but blue can drift into coldness, loneliness, and depression, while green can be sickly; the color of eldritch magicks, plagues, or madness. Purple carries royalty and edginess, as well as wealth and weirdness, both at once. Finally, the neutral colors (gray, beige, and brown) can create a subtle and toned-down image. Too much drab "realism," however, will rob your pages of any impact—they're best used to contrast with more vibrant colors!

How you choose to combine colors will give your work a unique style. Don't feel limited by convention: you're a shonen manga trailblazer, learning the rules in order to break them! As an exercise, try to color a whole page using shades of just one color, and see what effects you can create. Then go back to the same picture with a second, contrasting color, and see how you can make a two-tone image pop!

PRIMARY

Most people think of the primary colors as red, blue, and yellow. More accurately, they are cyan, magenta, and yellow. These colors can be combined to create any single color of the spectrum.

SECONDARY

Fewer people may be aware of the secondary colors: orange, purple, and green. Each can be made by mixing two of the primary colors together.

TERTIARY

The tertiary colors are created using one primary and one secondary color: yellow-orange, red-orange, red-purple, blue-purple, blue-green, and yellow-green.

CRAMMING ALL OF THESE COLORS INTO A COLOR WHEEL GIVES A SIMPLE OVERVIEW OF WHICH COLORS SHOULD BE USED IN CONJUNCTION WITH OTHERS.

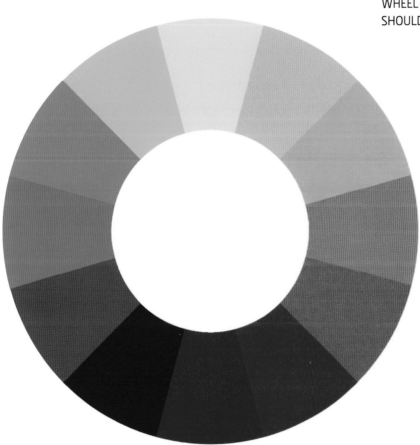

If you want colors that relate closely to each other, choose analogous colors—colors that are close together. By choosing several analogous shades, you can achieve a more subtle color scheme.

If you're feeling a little more daring, try complementary colors! Pick two colors directly opposite each other to achieve stunning contrast and vibrancy. However, be careful not to make your scheme too garish.

Finally, check out the triadic color scheme. As the name suggests, the idea is to choose three evenly-spaced colors from the wheel. One way to implement this is to choose two colors as the basic color scheme, with a third as a highlight for accent and depth. The third color is equally different to each of the base colors!

CHOOSING COLOR SCHEMES

WHILE TRADITIONALLY EXPENSIVE, IT IS GETTING A LOT CHEAPER TO PRINT COLOR MANGA, THANKS TO ONLINE PUBLISHING SITES LIKE LULU.COM AND CAFEPRESS.COM, WHICH ALLOW YOU TO PRINT OUT VERY SMALL RUNS OF YOUR WORK, OR SET UP A UNIQUE SHOP WHERE FRIENDS, FAMILY, AND READERS FROM ALL OVER THE WORLD CAN PRINT OUT THEIR OWN COPIES. COLORING CAN ALSO BE COMBINED WITH TONING TO PRODUCE SOME STRIKING WORK—AND MAKE THE PROCESS MORE FUN!

To begin coloring, you'll need to convert your page to RGB mode first, if it is currently in Grayscale. If you are using Photoshop, rather than Photoshop Elements, and are aiming toward professional printing, you may want to use CMYK format. This format produces much bigger file sizes, and does not support the full range of Photoshop Filters (you'll have to flip between RGB and CMYK if you want to use them), but the colors it uses look better on the printed page, as they correspond to the four inks used in printing (Cyan, Magenta, Yellow, and blacK). If you are going to publish your work online, RGB is the format for you, as it is designed for viewing on screen (monitors and TVs use a mixture of Red, Green, and Blue to produce their images).

Coloring a manga page is slightly different from coloring a poster. Because shonen pages contain several panels, you'll quickly paint yourself into a messy and unreadable corner if you don't plan your color schemes first. Take a deep breath and look over your page before you begin—you may even want to set up a palette of custom swatches, featuring colors you have found work well together. Here's how to set one up.

1 Select a color in the color picker.

2 Open Window > Swatches and the swatches palette will appear. Click the small inverted triangle at the top right and select New Swatch.

3 Your cursor changes to a paint bucket when you move it over an empty place in the swatch palette. Click with the paint bucket to fill the empty spot with your chosen color.

4 To replace a color in the swatch, select the color you want to place in it, move the cursor over the color you want to replace, and hold down the Shift key. When the cursor changes to a paint bucket, click to replace the old color.

5 Once you are happy with your swatch, click the small inverted triangle, and in the drop down menu, select Save Swatch. Remember: you can always change or add more colors to your custom color swatch.

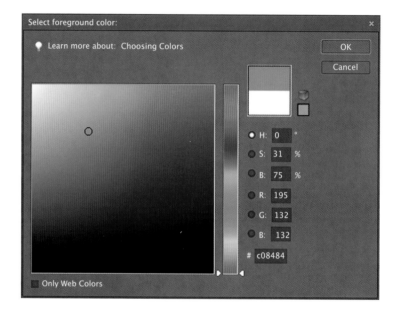

Tip Highly saturated colors rarely look good when combined (although some highly skilled artists are able to pull it off) and could make you look like an amateur. When you pick colors for your color swatches, choose the less saturated end of the spectrum for a more convincing effect. When you open up the "color picker" window, you'll see a field of tones for your chosen color, progressing from completely desaturated white and black on the left to fully saturated light and dark colors on the right. Try to avoid the top right corner, except for really strong visual effects!

You can also create a custom color palette from a color manga picture you really like. Here's how to do it.

1 Find the image you want to use (normally from the Internet), save it to your computer and open it in Photoshop.

2 To create a custom swatch from an image, convert it to an indexed palette image. Click Image > Mode > Indexed Color. In the pop-up window, there is a choice of colors. You can put the number of the colors you want on your swatch here. Don't pick too many, or you won't be able to find the colors you wanted! A number between 150 and 250 is in the right ballpark.

3 Now go to Image > Mode > Color Table to view the color palette extracted from this image. Click on Save to save the color palette, then click Cancel to exit. (Remember where you saved it so that you can load the palette later!)

4 Open the manga page you want to color and go to the swatches palette. Click Replace Swatches from the palette menu. Find the color palette you just generated (it'll have saved as an .act file) and load it.

5 Now you can pick any color from the palette and use it on your manga page!

SHONEN

BLOCKING IN BASE COLORS

FILLING IN BASE COLORS IS THE FIRST STEP IN EVERY COLORING PROCESS. IN THE MANGA AND COMICS INDUSTRY, THESE BASIC COLORS ARE KNOWN AS FLATS. BASE COLORS OR FLATS PROVIDE BLOCK AREAS OF FLAT COLOR THAT SERVE AS A BASE FOR THE MORE DETAILED COLORING TO FOLLOW—AND YOU CAN'T LIVE WITHOUT THEM! THEY ALSO ALLOW YOU TO PLAY WITH COMPLEMENTARY TONES AND COMPOSITIONS WITHOUT HAVING TO SPEND HOURS SHADING EACH PART OF A PAGE INDIVIDUALLY BEFORE REALIZING THAT THE COLORS YOU'VE CHOSEN CLASH, AND YOU'VE APPLIED THE SAME AMOUNT OF DETAIL TO EVERY PART OF THE PICTURE EQUALLY, CONFUSING THE READER'S EYE. STAVE OFF ALL OF THESE PROBLEMS BY FOCUSING ON THE BIG PICTURE DURING THE FLATS STAGE. CREATING BLOCKS OF SOLID COLOR ON A SEPARATE LAYER ALSO ALLOWS YOU TO RESELECT LARGE AREAS OF COLOR WITH THE MAGIC WAND TOOL WITH THE GREATEST OF EASE—KEEP A COPY OF YOUR FLATS LAYER, EVEN AFTER YOU START SHADING, SO THAT YOU CAN COME BACK TO AREAS OF COLOR LATER IF YOU AREN'T HAPPY WITH THEM.

PREPARING THE ARTWORK FOR TONE AND COLOR

When you have completed your line-art, you should prepare it to be colored or toned. It's important to flatten an image and make sure that no anti-aliasing is present: such "blurry" lines can prove tricky during coloring, as the Magic Wand finds it hard to pick up the hundreds of shades of gray that pop up around black lines, and Paint Bucket fills will stop before they reach a boundary line. Anti-aliasing is the way lines are blurred on screen to make diagonal and curved lines look smoother. While this creates a more pleasing visual effect in a final piece, it causes difficulties when coloring—and nothing is worse than ragged graytones around all of your lines!

You can compensate to some extent with the Magic Wand and Paint Bucket by using a high Threshold value in the Tool Options bar, but by far the best way is to remove all anti-aliasing and layers at this stage.

1 Choose Layers > Flatten Image from the menu. This will reduce the image to a single layer.

2 Choose Image > Mode > Bitmap. Leave the resolution as it is, but change the method to 50% Threshold. This means that any colors above 50% darkness will become black, and any below will become white. Don't forget, you'll have to convert back to RGB mode before you can color!

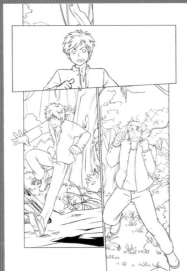

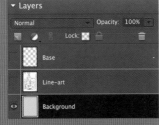

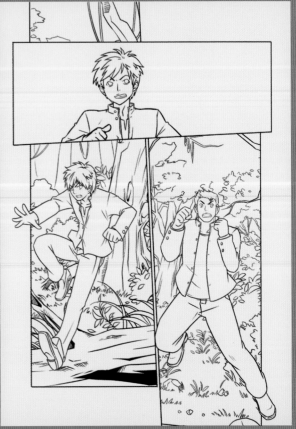

1 Start the base color process by ensuring the line-art is cleaned (filling in gaps between lines that should be solid, and erasing any stray lines that'll annoy you later)—an important step if you've scanned in your own art. Copy the line-art to a new layer, rename it something memorable, and set the mode to Multiply. This will allow colors on layers beneath or above to show through. Delete the information on the original line-art layer, rename it Base and leave the mode as Normal. To help make any gaps in your coloring obvious, create another new layer below your Base layer and flood fill it with a light pastel color (blues and greens are best).

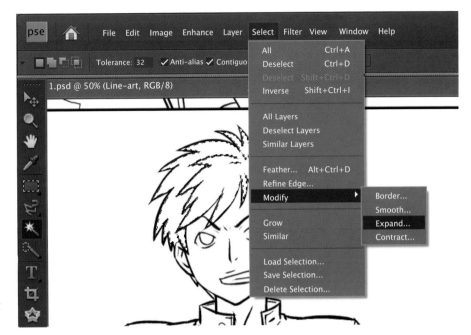

2 On the Base layer, use the Magic Wand tool to select an area you want to block color in. Set the tolerance to about 50, check Contiguous and Sample All Layers, and uncheck Anti-alias. Press and hold the Shift key to select multiple areas (all of one character's skin tones or hair, for instance) or press and hold the Alt key to deselect any areas you may have clicked by accident.

3 Now click Select > Modify > Expand, set the value to 1 and click OK. This expands the area of color out over the linework so that there are no gaps in the color when printed or viewed on screen.

4 Sometimes the line-art is "broken" (i.e. not joined up), which will cause your Magic Wand selection to "spill out" into adjacent areas. You can either Deselect your selection (Ctrl/Cmd + D) and close the line with the Pencil tool on the Line-Art layer, or use Alt and the Lasso tool to deselect the excess selection. If you've already selected multiple areas and don't want to lose your selection, a good "cheat" is to invert it by pressing Ctrl/Cmd + Shift + I, fix the gap with the Pencil tool, and return to your original selection by pressing Ctrl/Cmd + Shift + I again.

5 Using the Paint Bucket tool, with the mode set to Normal and opacity at 100%, fill the selected area with your chosen color on your base color layer. You can also get the same result by pressing "X" to switch your chosen color to the background color, and pressing delete. It's quicker over multiple areas!

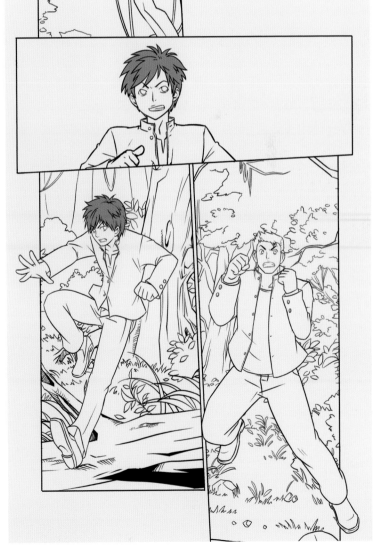

SHONEN

6 Sometimes you will want to use the Pencil tool to fill in small problem areas, or areas not fully enclosed by the line-art (for example, the pupils of your characters' eyes). Use the [and] keys, or the right-click menu, to increase or decrease the brush size.

7 Repeat the above steps to fill in all the colors. Coloring is a time-consuming process, but don't get frustrated if it takes a while—the results are worth it!

8 Use the Eraser tool to clean up any overlapping areas, or use the Pencil tool in the color you want to replace the overlap with.

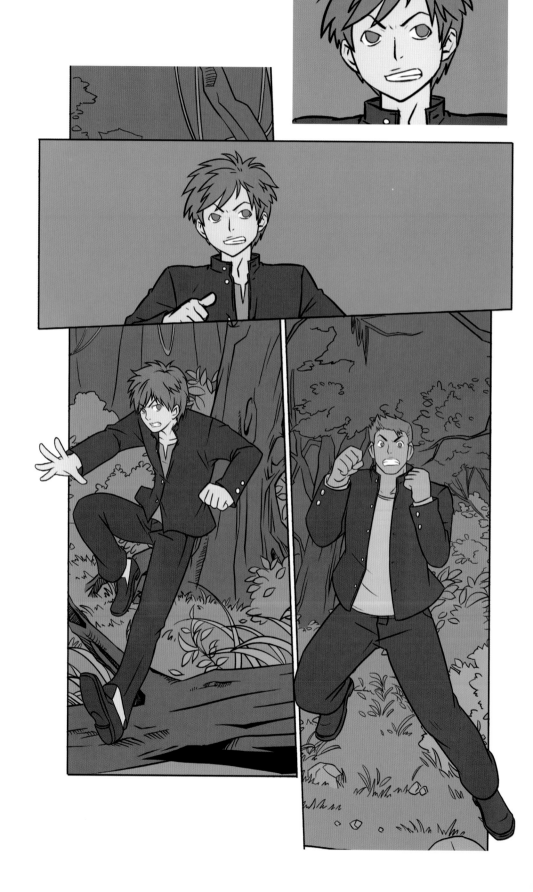

9 If one color you have filled looks out of place next to another, you can adjust it. Use the Magic Wand to select the area of color you want to change (if you've used the color in more than one location on your page, deselect Contiguous and the Wand will select all the places that color appears on the page), then go to Image > Adjustment > Hue/Saturation and push and pull the sliders until you're happy with the new color.

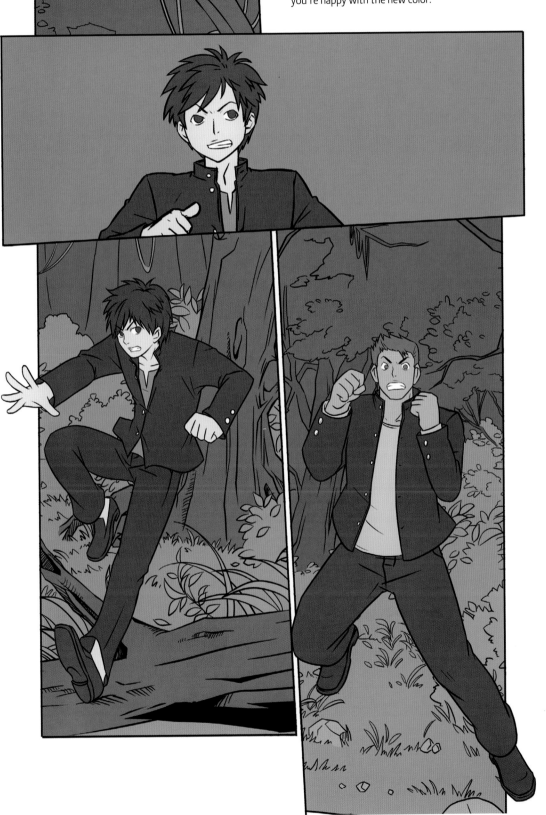

SHONEN
CEL SHADING

CEL SHADING IS A TERM THAT COMES FROM THE PAINTING STYLE USED ON JAPANESE ANIME CELS—IT REFERS TO A STYLE OF USING FLAT COLORS TO DENOTE LIGHT AND SHADE. YOU'LL RECOGNIZE IT IMMEDIATELY: A FLAT MID-TONE COLOR GIVEN DEPTH AND SHAPE BY A SECONDARY, DARKER SHADOW. THIS USE OF TWO-TONE, HIGH-CONTRAST SHADING HAS BECOME INTRINSICALLY ASSOCIATED WITH JAPANESE ANIMATION, AND, ALTHOUGH MANY WESTERN ANIMATION STUDIOS HAVE SINCE ADOPTED THE TECHNIQUE, IT'S STILL A FANTASTIC CHOICE FOR AUTHENTIC MANGA CHARACTERS.

THE BEST THING ABOUT CEL-STYLE SHADING IS IT COMBINES DYNAMISM AND A HIGH-QUALITY FINISH WITH A LOW LEVEL OF RENDERING, MAKING IT BY FAR THE QUICKEST COLORING METHOD!

CEL-STYLE SHADING IS VERY EASY TO EMULATE USING PHOTOSHOP, AND YOU CAN ACHIEVE THE RIGHT LOOK VERY QUICKLY BY MAKING THE MOST OF LAYERS, MEANING YOU GET MORE TIME TO FOCUS IN ON THE DETAILS, RATHER THAN TRYING TO GET YOUR OVERALL CEL LOOK TO WORK CORRECTLY. YOU'LL ALSO FIND THAT ANYTHING YOU LEARN FROM CEL SHADING CAN BE APPLIED TO OTHER COLORING STYLES—SUCH AS NATURAL MEDIA—AND THE KNOWLEDGE OF LIGHT AND SHADE YOU'LL PICK UP HERE WILL FORM THE BASIS FOR THE LIGHTING OF ANY IMAGE, NO MATTER THE SHADING TECHNIQUE. PLUNGE IN, LEARN ALL YOU CAN, THEN DECIDE IF THIS IS THE COLORING TECHNIQUE FOR YOU!

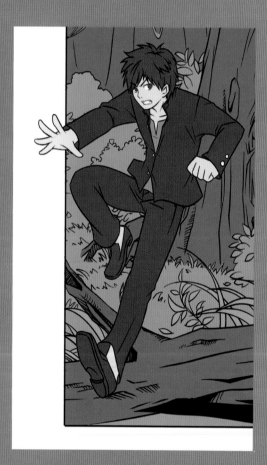

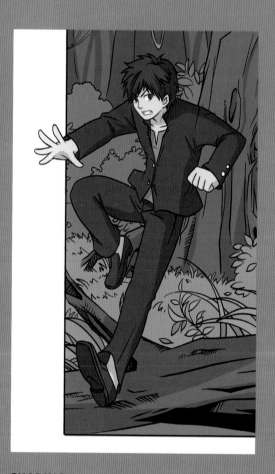

ORIGINAL
This page has no shading, just simple base colors. The most important aspect of cel shading is to understand how light falls on an object, and how light and shadows can best pick out a shape.

SHADING
The lightest parts of an object are those facing a light source, the darkest parts those that face away from the light. Unless the light source is very small and weak (such as the glow from a TV screen or a flickering flame) the light will appear to affect the object equally—roughly the same amount of light falls on everything that points towards the light.

SHADOWS

Effectively defining your shadows helps to sell the illusion of solidity in your images. As well as ensuring objects are shaded correctly with regards to the light, you should pay attention to how different objects and characters interrupt the light with their bodies or shapes. Believable scenes are those where objects within them are affecting and interacting with one another. Here, you can see the bushes and tress casting shadows in the background, integrating them with the environment. Secondly, the character also casts shadows on himself in certain places, i.e on the inside of his bottom trouser leg.

DARK SHADOWS

With shiny materials such as plastic or skin (in some instances), you may wish to further define the shadows. Giving these areas a heavier shadow can help to define the shape of the object more vividly and show the different amounts of light being reflected from it.

HIGHLIGHTS

Highlights are applied with one simple rule: the shinier the object, the greater the highlight! In this image, highlights have been added facing towards the main light source. You could also place some additional highlights from the opposite direction, implying another light source nearby. This style of backlight is an easy and popular method to give an object more volume.

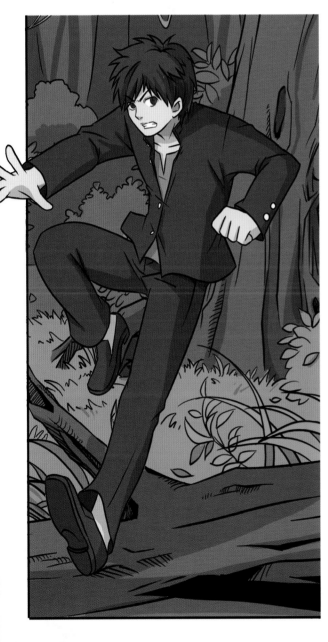

SHONEN

APPLYING BASIC CEL SHADING

1 Create a new layer on top of your base colors (see page 52), and call it "Shading". Set the layer's blending mode to Multiply.

2 Go to the base layer and use the Magic Wand tool to select the areas you want to color. Set the tolerance to 0 and uncheck Contiguous and Sample All Layers.

3 With the area selected, move back to the shading layer. When coloring using a single tone over a variety of base colors, permutations of gray are the norm—the darker the shadow, the less saturated it is. Using gray not only lowers the lightness of shaded areas, but also decreases the saturation, sapping them of color. However, you don't have to use a pure gray— you may want to inject some color, depending on the mood of your page. For example, a night scene might respond well to a purple-gray, while a warm sunny day calls for something more pinkish or yellow. To shade, you'll want the Paint Brush tool. Choose a hard-edged brush and set the opacity and flow to 100%.

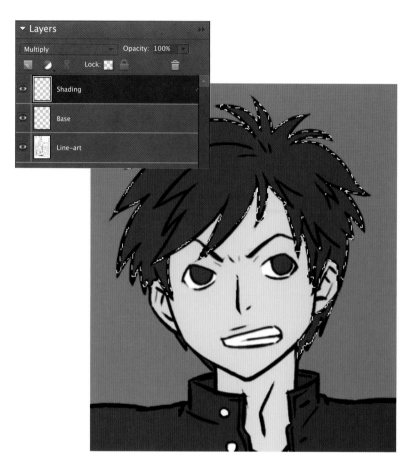

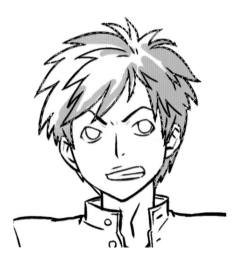

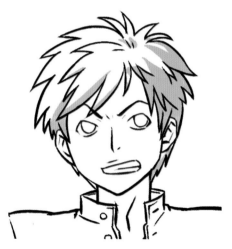

4 Apply the shading, using the Eraser tool to correct any mistakes, and also to sharpen up the end of any lines that you wish to taper to a point. Remember to paint in your shadows consistently—make sure all your major shadows are facing away from the same light source.

5 You can choose a darker shade of the same shading color to define deeper shadows.

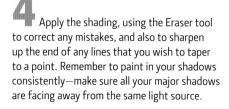

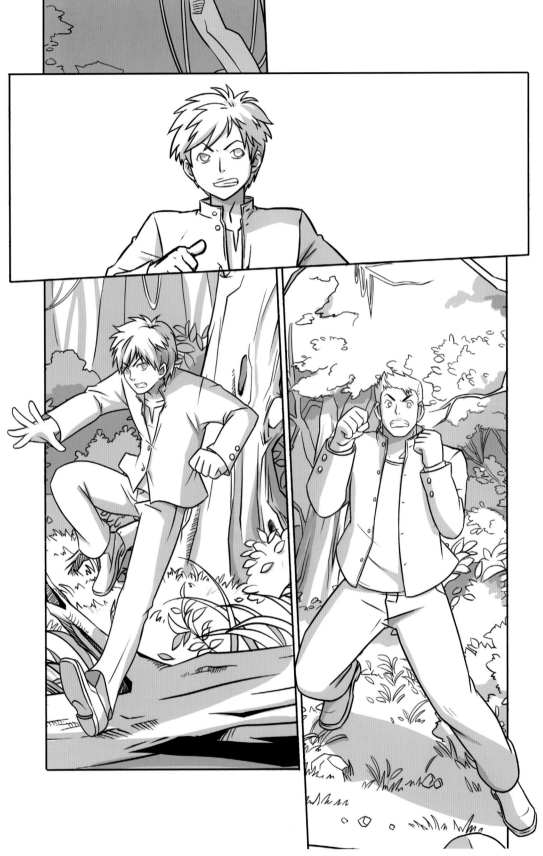

6 Once you've finished painting, use the Hue/Saturation tool to adjust the color of your shadows until you are completely satisfied. This overlay method will save you lots of time, and is an awesome shortcut to professional results!

SHONEN

ADDING HIGHLIGHTS AND DETAIL

1 Create a new layer above the color layer. Label this "Highlights." Set the layer to Screen mode, so only that layer will lighten. Set opacity to about 60%.

2 Using a white-ish color, apply areas of light, bearing your light source in mind. Consider the type of material, and whether or not it would in fact have highlights. You might find that most materials would be better left without.

3 As with the shading, it's advisable to turn off the base color layer's visibility from time to time to check that your shading is accurate and that no areas have been missed.

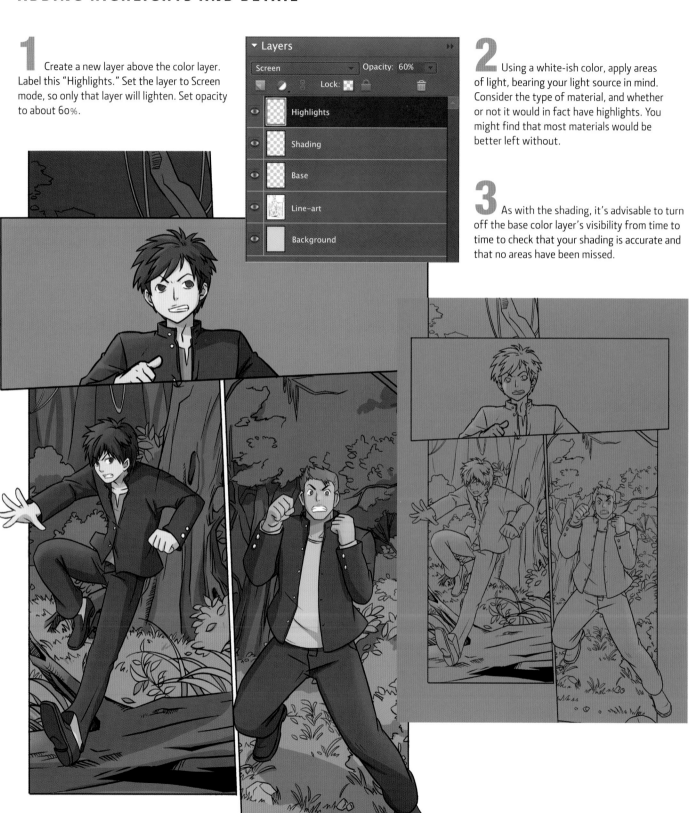

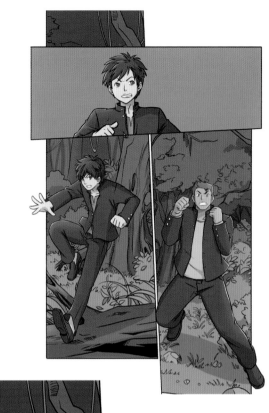

4 Create another layer, labeled Strong Highlights. Leave this at 100% opacity.

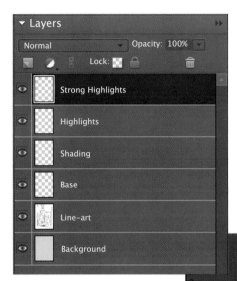

5 Add the brightest highlights to areas such as metal, hair, and shiny areas of skin. Continue using white, and begin to add small dots, lines, and glints of white light to areas which would reflect the light in large amounts.

6 Finally, add in any intricate details, turn on all the layers, and revel in the finished image!

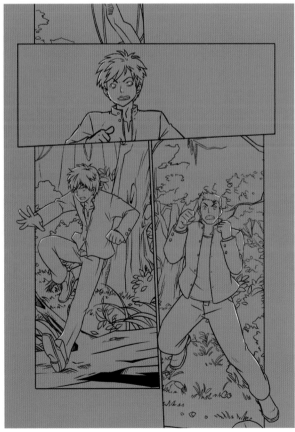

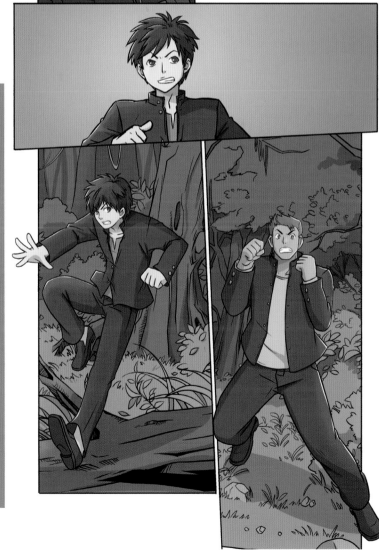

SHONEN
NATURAL MEDIA

SIMULATED NATURAL-MEDIA COLORING IS POPULAR WITH MANGA ARTISTS IN BOTH JAPAN AND THE WEST. IF YOU FIND THAT YOUR COLORING TENDS TO LOOK A LITTLE CLINICAL AND DIGITAL, THEN YOU'LL GET A KICK OUT OF THIS METHOD, WHICH ADDS IN SOME OF THE TEXTURES AND FLAWS YOU'LL FIND IN TRADITIONAL BRUSH-AND-PEN COLORING, GIVING BACK THE FLUIDITY AND WARMTH DIGITAL PERFECTION SOMETIMES STEALS. YOU COULD PICK UP A PROGRAM SPECIALLY DESIGNED FOR NATURAL MEDIA SIMULATION, LIKE COREL PAINTER, BUT YOU SHOULD FIND THAT BOTH PHOTOSHOP AND PHOTOSHOP ELEMENTS CAN MORE THAN HOLD THEIR OWN IN THIS AREA.

1 After blocking in basic colors in the base layer, duplicate the layer (right-click on the layer and select Duplicate Layer or click Layer > Duplicate Layer). Rename the duplicate "Color" and leave its mode on normal. Move the color layer above your base layer. Keep the original base layer, as it will help you select areas of color with the Magic Wand tool later. You will be doing all of your painting work on the duplicate. Careful, though—don't use the Eraser to correct mistakes, as it will just erase through to the layer below! If you need to tidy up, use the Paint Brush tool to paint over the fault with the original color.

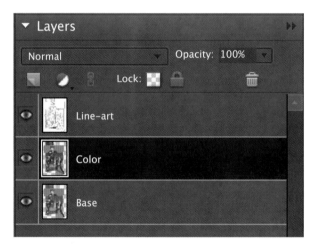

2 Select areas of a specific color within your image to start with, such as a character's skin color, using the Magic Wand with Contiguous unchecked. Choose a color that's a few shades darker than the color to shade with (but not a shade of gray). You will be adding shadows with the Paint Brush tool, so select a soft tip brush and set the opacity to roughly 30%.

3 You can paint directly onto the color layer within your Magic Wand selection (selecting each area of color like this keeps your shading inside the lines). With an opacity as low as 30%, you can build the darker color up gradually, overpainting the places with darker shadows; even adjusting the opacity down further for lighter areas of shadow. If you think the shadows are not dark enough, simply choose an even darker tone. Some people find that picking the darkest tone you want to work with, and painting back towards the light works for them as an alternative rendering method. Try it yourself and see which one you prefer.

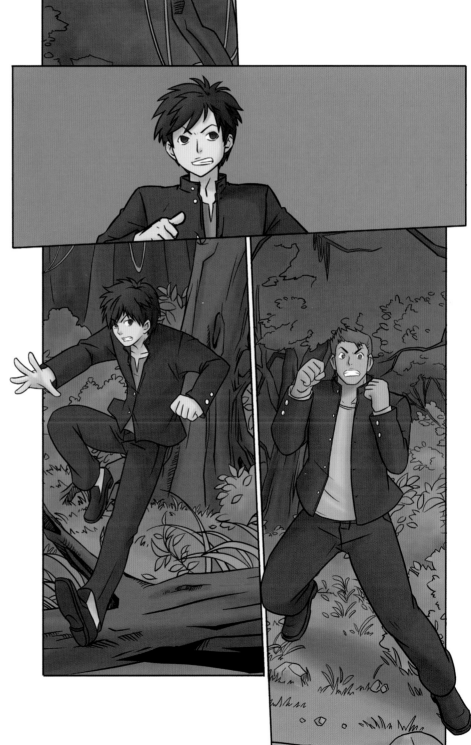

SHONEN

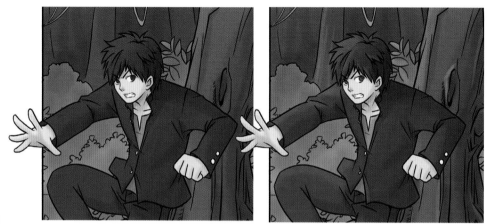

4 Back to our original method. Once the shadows are complete, move on to the highlights—choose a color lighter than the original skin tone and paint areas of skin that especially catch the light. Use your favorite soft-tipped Brush at low opacity to build the highlights up gradually.

5 Repeat the process for the other parts and tones of the picture. Pay close attention to the types of material you're painting, and how reflective or shiny they might be. Don't forget to adjust the Hue/Saturation on areas of color to tweak them until you're satisfied. Here's where keeping your base colors as a separate layer comes in handy, as painted areas of color are tough to select in their entirety with the Magic Wand. Lucky for you, you kept a copy of your flats: just click back to the base layer, select the area of flat color you want to adjust, then flip back to the color layer and alter as necessary.

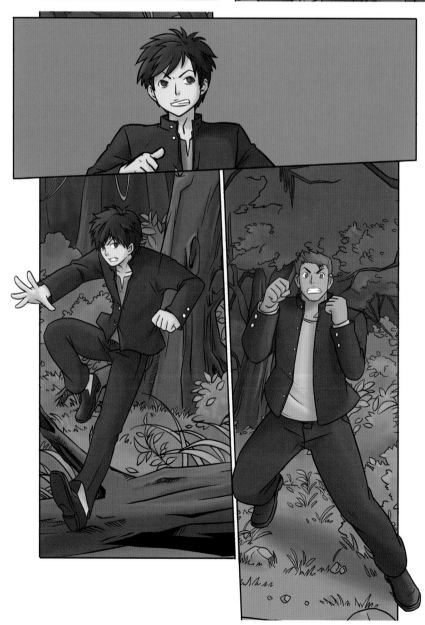

6 When you finish coloring your image, you can add your strong highlights. Create a new layer on top of the color layer, name it "Highlights," and leave the mode as Normal. Pick a hard-tipped Brush and set the opacity to 80%–100%, then paint in the bright highlights to finish off your piece.

7 Finally, as before with cel shading, add the small details.

SHONEN
DESIGNING COVER ART

COVERS ARE ESSENTIAL FOR LETTING YOUR POTENTIAL READERS KNOW JUST WHAT'S INSIDE YOUR WORK OF SHONEN GENIUS, HOW YOUR BOOK DIFFERS FROM THE OTHER MANGA ON THE MARKETPLACE, AND WHAT KIND OF WILD CHARACTERS THEY CAN EXPECT TO FOLLOW OVER THE COURSE OF YOUR ADVENTURE! A GOOD COVER IS THE DIFFERENCE BETWEEN SOMEONE PICKING UP YOUR BOOK . . . AND THEM PICKING UP SOMETHING ELSE. IT'S BEST TO WAIT UNTIL YOUR STORY IS WRITTEN, TONED, COLORED, AND LETTERED BEFORE YOU START ON IT, THE BETTER TO CAPTURE THE MOOD AND ATMOSPHERE OF YOUR MASTERPIECE—NOT TO MENTION ITS MOST THRILLING SCENES!

The most common cover design you'll see is a pin-up image of your main characters—and after spending a book with them, you should know them inside-out by now. The cover should suggest some of the relationships between them—the hero and his gag-prone sidekick, the ominous villain, the love interest—which means this is a fantastic opportunity to break out your best character expressions, suggest emotional states and tension, and add some eye-catching humor! You'll be surprised at how much you can tell with a single image. For shonen manga, never underestimate the selling power of a cool bit of tech, either, from a slick sports car to a robot, monster, costume, or even a unique "artifact" like a priceless, custom electric guitar or self-forged weapon!

Some manga books may get away with blank backgrounds on the covers, but the majority of them get a little more creative. The background doesn't have to be complicated—often an abstract pattern or a single solid color will be sufficient—but you may want to anchor your characters in a real location with a drawing of a building or place. Why not add excitement to your picture by placing your illustrated characters into a photographic background you have taken? To create a background, just drop your chosen image into a layer underneath your finished character art.

FINISHING OFF!

YOU'RE ALMOST AT THE END OF YOUR FIRST SHONEN ADVENTURE. CONGRATULATIONS! IT'S TIME TO GET YOUR CREATION OUT INTO THE WORLD.

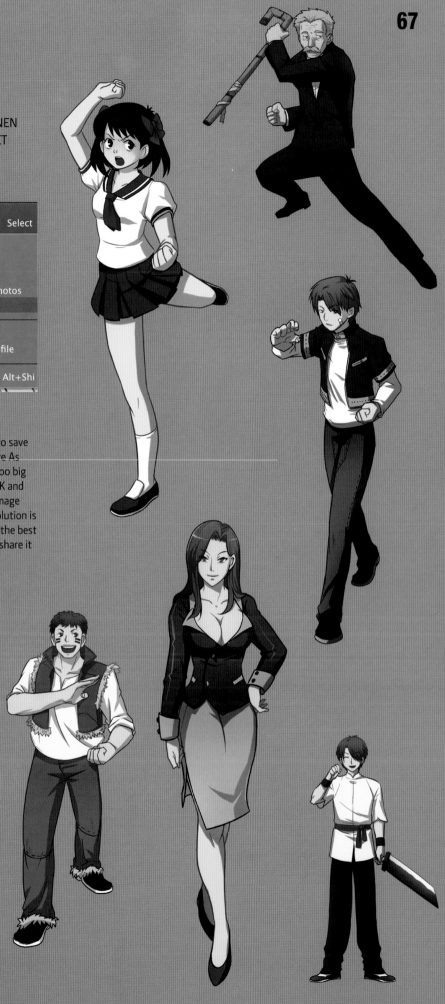

1 If you want to publish your title online, you'll need to save your pages as JPEGs. Open the PSD file and click File > Save As and choose JPEG as the saving format. If the JPEG file is too big to upload (you'll probably want a file size of between 500K and 1MB), change the image size by clicking Image > Resize> Image Size and set the resolution to a lower number. Screen resolution is 72 dpi, and you'll find that around 500–600 pixels wide is the best for on-screen legibility. Now you can upload it online and share it with your friends.

2 If you want to print your book out, simply open the PSD file you want to print and click File > Print. In the pop up window, set the scale to 100% and select Print on the right. Don't try to resize these pages, as you might create clashing moiré patterns with your graytones.

SHONEN

02 //
THE CATALOG

ONCE YOU HAVE DECIDED ON YOUR STORY AND SCRIPT, YOU NEED TO PICK YOUR HEROIC LEADS, SCINTILLATING SUPPORTING CAST, AND OUTRAGEOUS OPPONENTS. THE CATALOG ACTS AS A GALLERY OF IMAGES FOR YOU TO CHOOSE FROM, AND THE CHARACTERS SECTION LISTS SOME SAMPLE CAST MEMBERS IN BOTH FRONT AND SIDE PROFILE, WITH NOTES ON WHICH PHOTOSHOP LAYERS HAVE BEEN USED TO CREATE EACH VARIATION. LEADING, OR THE MAIN SUPPORT CHARACTERS ALSO HAVE SEPARATE ACTION LAYERS.

SHONEN
MALE LEAD CHARACTERS

THE MALE LEAD IS THE MOST IMPORTANT CHARACTER IN YOUR STORY, THE ENTRY POINT TO YOUR WORLD FOR YOUR READER, AND THE CHARACTER THAT MUST GROW AND CHANGE THE MOST ACROSS THE COURSE OF HIS JOURNEY. WE'VE SUPPLIED DOZENS OF DIFFERENT LAYERS, OFFERING YOU THE OPPORTUNITY TO MOLD COUNTLESS DIFFERENT HEROES—ALL OF WHOM HAVE A LOT TO LEARN, AND EVEN MORE TO PROVE!

FRONT LAYERS

	accessory 1
	accessory 2
	accessory 3
	accessory 4
	eyes 1
	eyes 2
	eyes 3
	eyes 4
	mouth 1
	mouth 2
	mouth 3
	mouth 4
	mouth 5
	head 1
	head 2
	arms 1_1
	arms 1_2
	arms 1_3
	arms 1_4
	arms 2_1
	arms 2_2
	arms 2_3
	arms 2_4
	arms 3_1
	arms 3_2
	arms 3_3
	arms 3_4

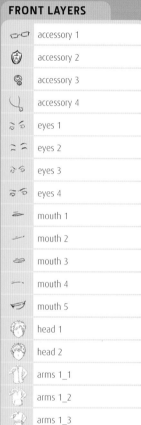

	legs 1_1
	legs 1_2
	legs 1_3
	legs 1_4
	legs 2_1
	legs 2_2
	legs 2_3
	legs 2_4
	legs 3_1
	legs 3_2
	legs 3_3
	legs 3_4

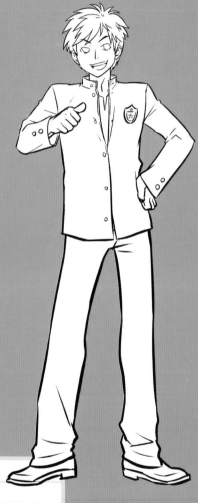

SCHOOLBOY
FRONT

Accessory 2
Eyes 1
Mouth 5
Head 1
Arms 1_1
Legs 1_1

SIDE LAYERS

	accessory 1
	accessory 2
	accessory 3
	accessory 4
	eyes 1
	eyes 2
	eyes 3
	eyes 4
	mouth 1
	mouth 2
	mouth 3
	mouth 4
	mouth 5
	head 1
	head 2
	arms 1_1
	arms 1_2
	arms 1_3
	arms 1_4
	arms 2_1
	arms 2_2
	arms 2_3
	arms 2_4
	arms 3_1
	arms 3_2
	arms 3_3
	arms 3_4
	legs 1_1
	legs 1_2
	legs 1_3
	legs 1_4
	legs 2_1
	legs 2_2
	legs 2_3
	legs 2_4
	legs 3_1
	legs 3_2
	legs 3_3
	legs 3_4

SCHOOLBOY
SIDE

Accessory 3
Eyes 1
Mouth 4
Head 1
Arms 2_1
Legs 2_1

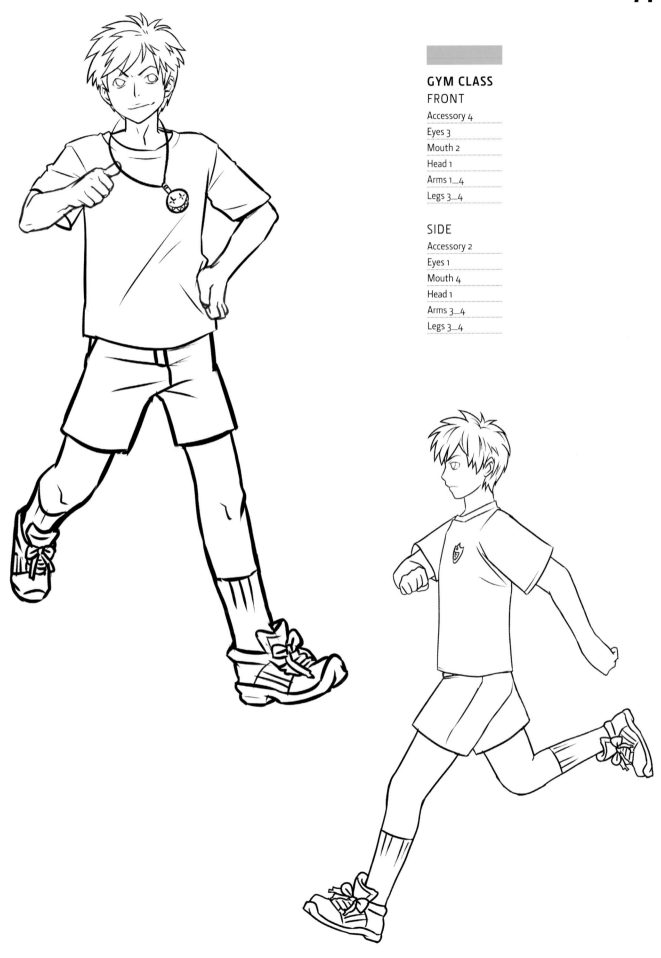

GYM CLASS
FRONT
Accessory 4
Eyes 3
Mouth 2
Head 1
Arms 1_4
Legs 3_4

SIDE
Accessory 2
Eyes 1
Mouth 4
Head 1
Arms 3_4
Legs 3_4

SHONEN

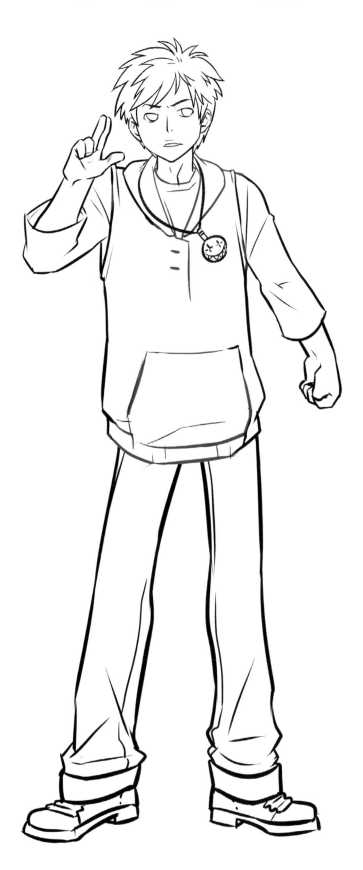

STREET
FRONT
Accessory 4
Eyes 4
Mouth 1
Head 1
Arms 3_2
Legs 1_2

SIDE
Accessory 1
Eyes 2
Mouth 3
Head 2
Arms 3_2
Legs 2_2

UNIFORM
FRONT
Accessory 3
Eyes 1
Mouth 2
Head 2
Arms 2_1
Legs 2_1

SIDE
Accessory 2 + 4
Eyes 3
Mouth 5
Head 1
Arms 1_4
Legs 2_3

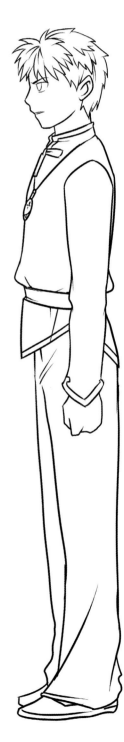

NINJA
FRONT
Accessory 1
Eyes 2
Mouth 4
Head 2
Arms 2_3
Legs 2_3

SIDE
Accessory 4
Eyes 4
Mouth 1
Head 2
Arms 1_3
Legs 1_3

SHONEN

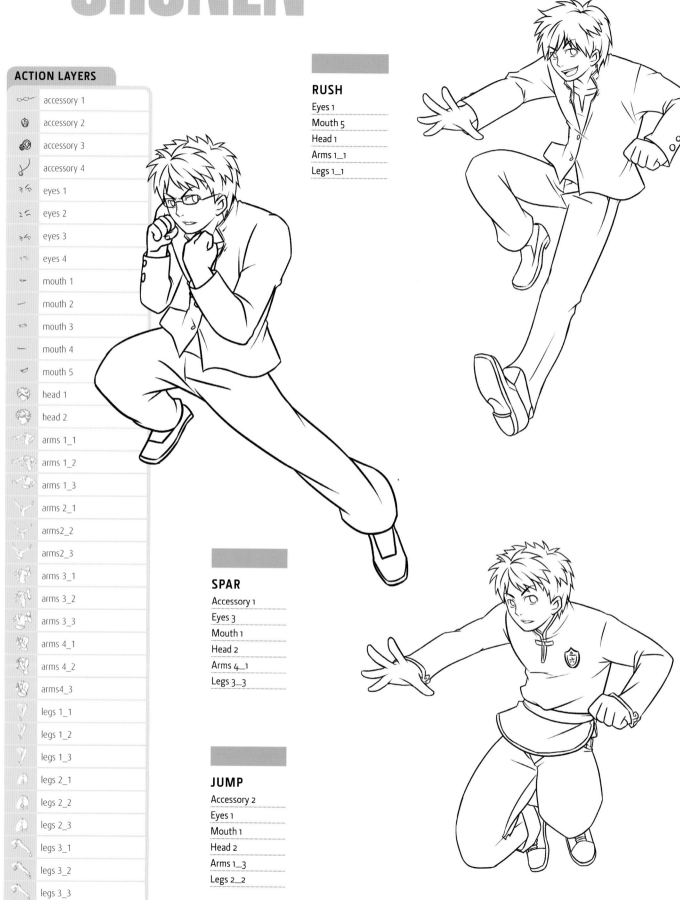

ACTION LAYERS

accessory 1	
accessory 2	
accessory 3	
accessory 4	
eyes 1	
eyes 2	
eyes 3	
eyes 4	
mouth 1	
mouth 2	
mouth 3	
mouth 4	
mouth 5	
head 1	
head 2	
arms 1_1	
arms 1_2	
arms 1_3	
arms 2_1	
arms2_2	
arms2_3	
arms 3_1	
arms 3_2	
arms 3_3	
arms 4_1	
arms 4_2	
arms4_3	
legs 1_1	
legs 1_2	
legs 1_3	
legs 2_1	
legs 2_2	
legs 2_3	
legs 3_1	
legs 3_2	
legs 3_3	

RUSH
Eyes 1
Mouth 5
Head 1
Arms 1_1
Legs 1_1

SPAR
Accessory 1
Eyes 3
Mouth 1
Head 2
Arms 4_1
Legs 3_3

JUMP
Accessory 2
Eyes 1
Mouth 1
Head 2
Arms 1_3
Legs 2_2

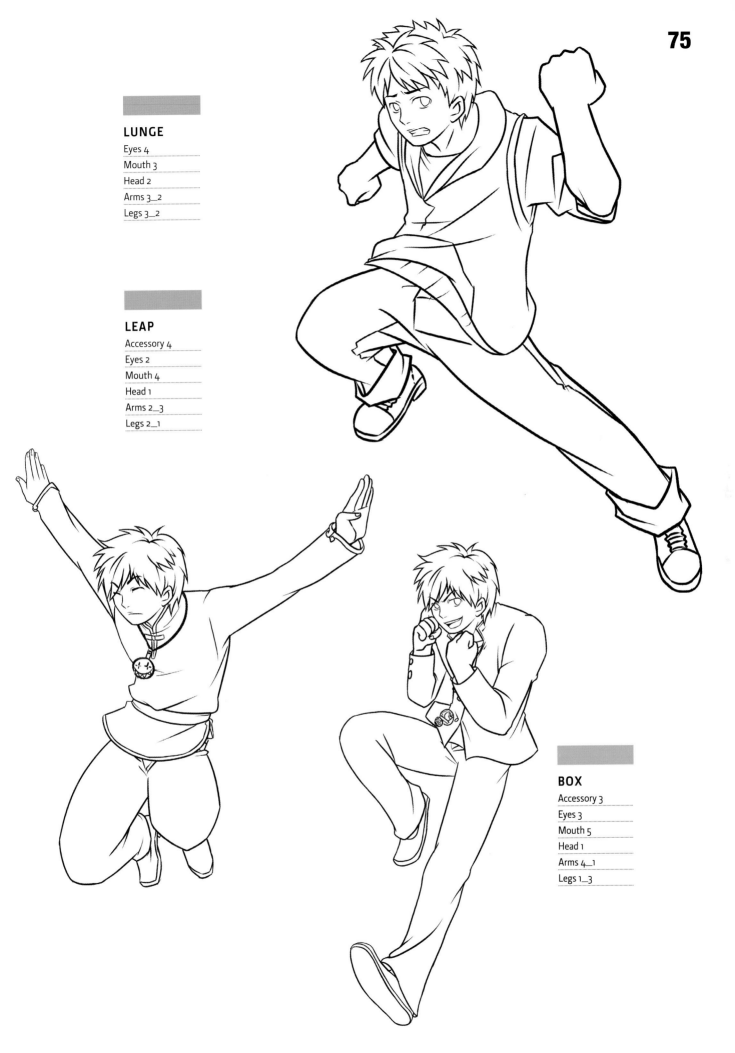

LUNGE

Eyes 4

Mouth 3

Head 2

Arms 3__2

Legs 3__2

LEAP

Accessory 4

Eyes 2

Mouth 4

Head 1

Arms 2__3

Legs 2__1

BOX

Accessory 3

Eyes 3

Mouth 5

Head 1

Arms 4__1

Legs 1__3

SHONEN

SPORT LAYERS

	accessory 1
	accessory 2
	eyes 1
	eyes 2
	eyes 3
	eyes 4
	mouth 1
	mouth 2
	mouth 3
	mouth 4
	mouth 5
	head 1
	head 2
	arms 1_1
	arms 1_2
	arms 2_1
	arms2_2
	arms 3_1
	arms 3_2
	legs 1_1
	legs 1_2
	legs 2_1
	legs 2_2
	legs 3_1
	legs 3_2
	legs 4_1
	legs 4_2

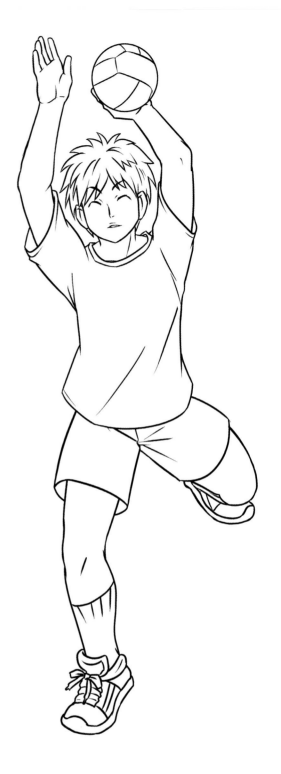

VOLLEY BOY

Accessory 2
Eyes 2
Mouth 1
Head 1
Arms 3_1
Legs 1_1

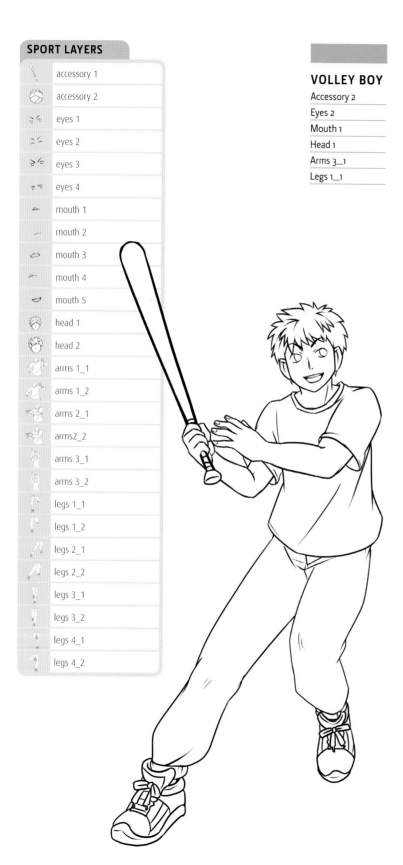

BASEBALL BATTER

Accessory 1
Eyes 1
Mouth 5
Head 2
Arms 2_1
Legs 2_2

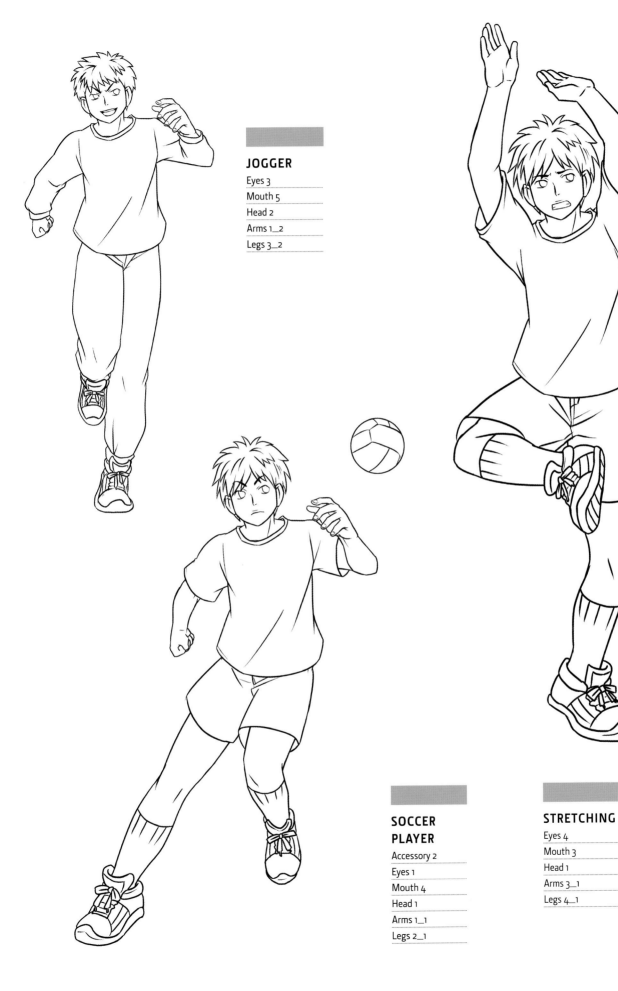

JOGGER

Eyes 3
Mouth 5
Head 2
Arms 1_2
Legs 3_2

**SOCCER
PLAYER**

Accessory 2
Eyes 1
Mouth 4
Head 1
Arms 1_1
Legs 2_1

STRETCHING

Eyes 4
Mouth 3
Head 1
Arms 3_1
Legs 4_1

SHONEN
FEMALE LEAD CHARACTERS

FROM GIRLS NEXT DOOR TO FEMME FATALES, SEXY SUBSTITUTE
TEACHERS TO MACHIAVELLIAN MOTHERS, THE WOMEN IN
YOUR SHONEN MANGA CAN HAVE AS MUCH AN EFFECT ON THE
DIRECTION OF THE ADVENTURE AS THE MEN. WITH DOZENS OF
OPTIONS ON DISPLAY, YOU CAN BE REST ASSURED YOU CAN CREATE
THE PERFECT ROMANTIC FOIL OR FEMININE OBSTACLE TO ADD
DEPTH AND HUMOR TO YOUR TALE.

FRONT LAYERS

	accessory 1
	accessory 2
	accessory 3
	accessory 4
	eyes 1
	eyes 2
	eyes 3
	eyes 4
	mouth 1
	mouth 2
	mouth 3
	mouth 4
	mouth 5
	head 1
	head 2
	arms 1_1
	arms 1_2
	arms 1_3
	arms 1_4
	arms 2_1
	arms 2_2
	arms 2_3
	arms 2_4
	arms 3_1
	arms 3_2
	arms 3_3
	arms 3_4
	legs 1_1
	legs 1_2
	legs 1_3
	legs 1_4
	legs 2_1
	legs 2_2
	legs 2_3
	legs 2_4
	legs 3_1
	legs 3_2
	legs 3_3
	legs 3_4

SIDE LAYERS

	accessory 1
	accessory 2
	accessory 3
	accessory 4
	eyes 1
	eyes 2
	eyes 3
	eyes 4
	mouth 1
	mouth 2
	mouth 3
	mouth 4
	mouth 5
	head 1
	head 2
	arms 1_1
	arms 1_2
	arms 1_3
	arms 1_4
	arms 2_1
	arms 2_2
	arms 2_3
	arms 2_4
	arms 3_1
	arms 3_2
	arms 3_3
	arms 3_4

	legs 1_1
	legs 1_2
	legs 1_3
	legs 1_4
	legs 2_1
	legs 2_2
	legs 2_3
	legs 2_4
	legs 3_1
	legs 3_2
	legs 3_3
	legs 3_4

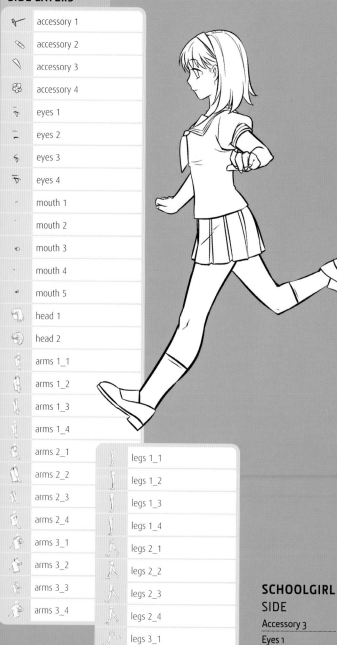

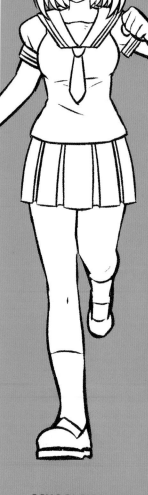

SCHOOLGIRL
SIDE
Accessory 3
Eyes 1
Mouth 1
Head 1
Arms 3_1
Legs 3_1

SCHOOLGIRL
FRONT
Accessory 2
Eyes 2
Mouth 5
Head 1
Arms 3_1
Legs 3_1

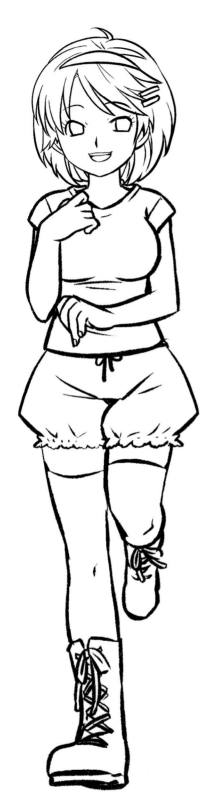

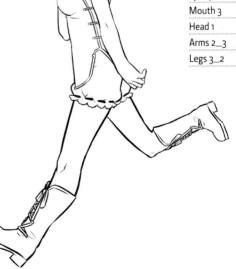

CASUAL
FRONT
Accessory 2 + 4
Eyes 2
Mouth 5
Head 2
Arms 1_4
Legs 3_2

SIDE
Accessory 2
Eyes 4
Mouth 4
Head 2
Arms 2_4
Legs 2_2

CUTE GIRL
FRONT
Accessory 4
Eyes 5
Mouth 1
Head 1
Arms 1_3
Legs 1_3

SIDE
Accessory 1 + 3
Eyes 3
Mouth 3
Head 1
Arms 2_3
Legs 3_2

SHONEN

ANGRY
FRONT
Accessory 4
Eyes 3
Mouth 3
Head 2
Arms 3_3
Legs 2_3

SIDE
Accessory 4
Eyes 1
Mouth 1
Head 2
Arms 3_3
Legs 2_4

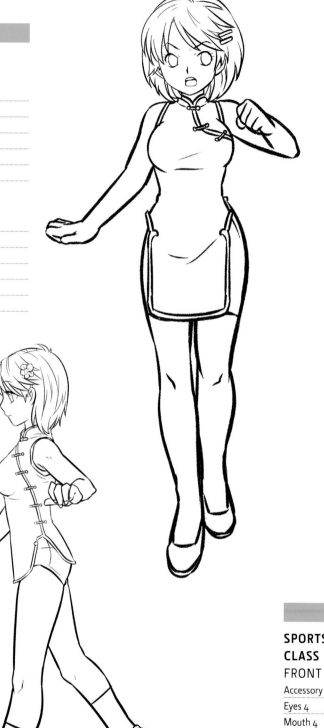

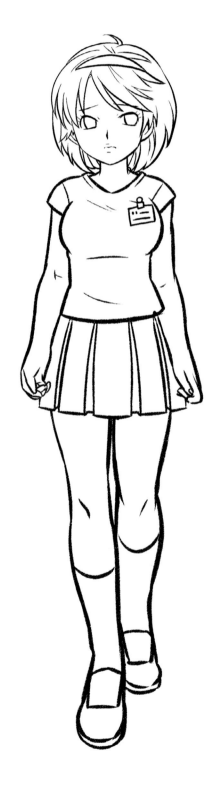

**SPORTS
CLASS**
FRONT
Accessory 2 + 3
Eyes 4
Mouth 4
Head 2
Arms 2_4
Legs 2_1

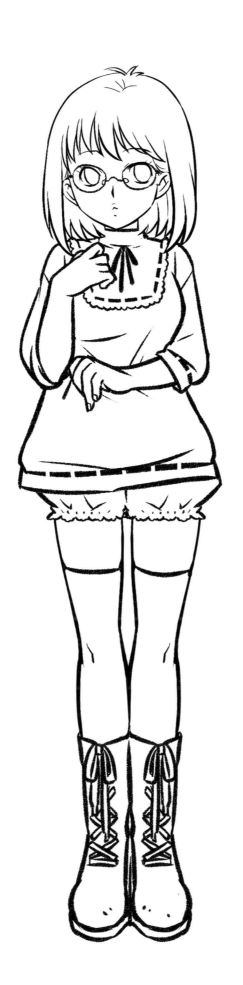

STUDY TIME
FRONT
Accessory 1
Eyes 1
Mouth 1
Head 1
Arms 1_2
Legs 1_2

SIDE
Accessory 4
Eyes 2
Mouth 3
Head 1
Arms 1_2
Legs 2_3

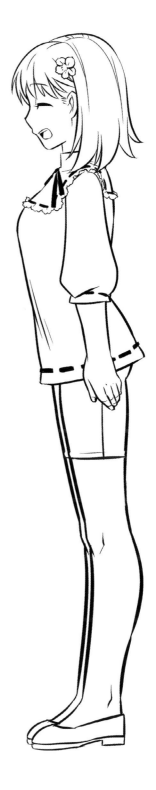

SHONEN

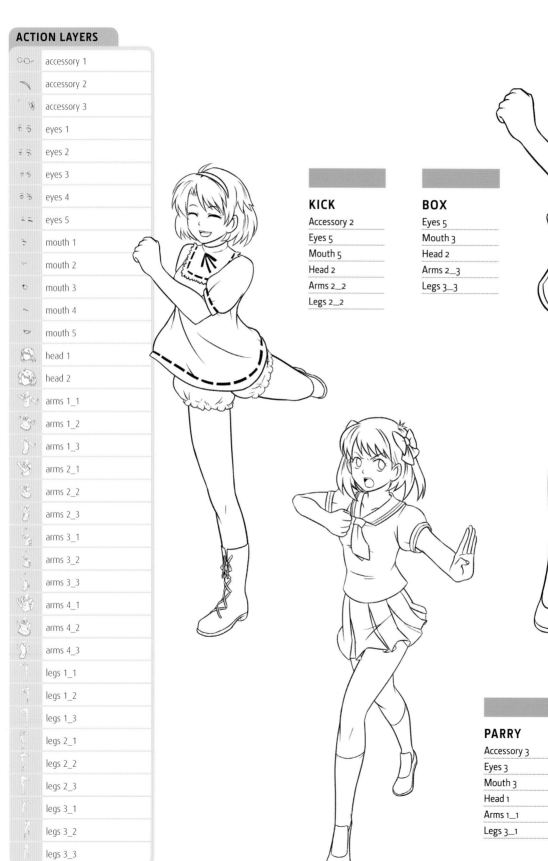

KICK
Accessory 2
Eyes 5
Mouth 5
Head 2
Arms 2_2
Legs 2_2

BOX
Eyes 5
Mouth 3
Head 2
Arms 2_3
Legs 3_3

PARRY
Accessory 3
Eyes 3
Mouth 3
Head 1
Arms 1_1
Legs 3_1

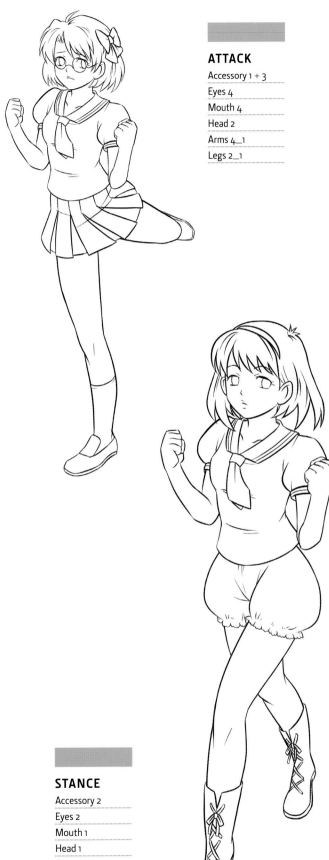

ATTACK

Accessory 1 + 3

Eyes 4

Mouth 4

Head 2

Arms 4_1

Legs 2_1

STRETCH

Accessory 4

Eyes 1

Mouth 1

Head 1

Arms 4_3

Legs 1_3

STANCE

Accessory 2

Eyes 2

Mouth 1

Head 1

Arms 4_1

Legs 3_2

SHONEN
SUPPORTING CHARACTERS

THE SUPPORTING CHARACTERS' FILES OFFER A RANGE OF OPTIONS FOR YOUR SECONDARY CHARACTERS. CHOCK FULL OF MIX-AND-MATCH EXPRESSIONS AND ACCESSORIES, THESE CHARACTERS OFFER YOU THE OPPORTUNITY TO BUILD EVERYTHING FROM VILLAINS TO TEACHERS, WARRIOR MENTORS TO BIKER GANG MEMBERS, AS WELL AS EVIL SCIENTISTS AND DEADLY NINJA!

SUPPORTING 1

SIDE LAYERS

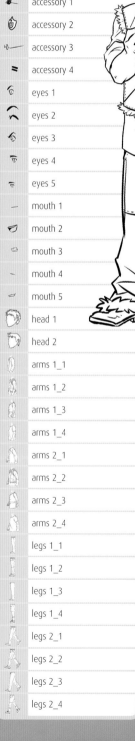

	accessory 1
	accessory 2
	accessory 3
	accessory 4
	eyes 1
	eyes 2
	eyes 3
	eyes 4
	eyes 5
	mouth 1
	mouth 2
	mouth 3
	mouth 4
	mouth 5
	head 1
	head 2
	arms 1_1
	arms 1_2
	arms 1_3
	arms 1_4
	arms 2_1
	arms 2_2
	arms 2_3
	arms 2_4
	legs 1_1
	legs 1_2
	legs 1_3
	legs 1_4
	legs 2_1
	legs 2_2
	legs 2_3
	legs 2_4

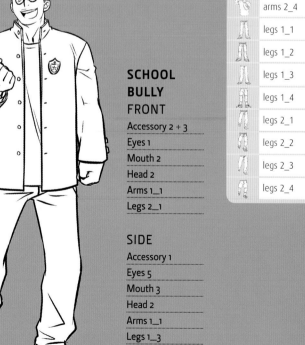

WAR PAINT
FRONT
Accessory 4
Eyes 5
Mouth 5
Head 2
Arms 1_2
Legs 1_2

SIDE
Accessory 4
Eyes 3
Mouth 5
Head 2
Arms 2_2
Legs 2_2

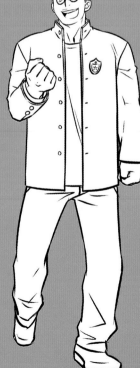

SCHOOL BULLY
FRONT
Accessory 2 + 3
Eyes 1
Mouth 2
Head 2
Arms 1_1
Legs 2_1

SIDE
Accessory 1
Eyes 5
Mouth 3
Head 2
Arms 1_1
Legs 1_3

FRONT LAYERS

	accessory 1
	accessory 2
	accessory 3
	accessory 4
	eyes 1
	eyes 2
	eyes 3
	eyes 4
	eyes 5
	mouth 1
	mouth 2
	mouth 3
	mouth 4
	mouth 5
	head 1
	head 2
	arms 1_1
	arms 1_2
	arms 1_3
	arms 1_4
	arms 2_1
	arms 2_2
	arms 2_3
	arms 2_4
	legs 1_1
	legs 1_2
	legs 1_3
	legs 1_4
	legs 2_1
	legs 2_2
	legs 2_3
	legs 2_4

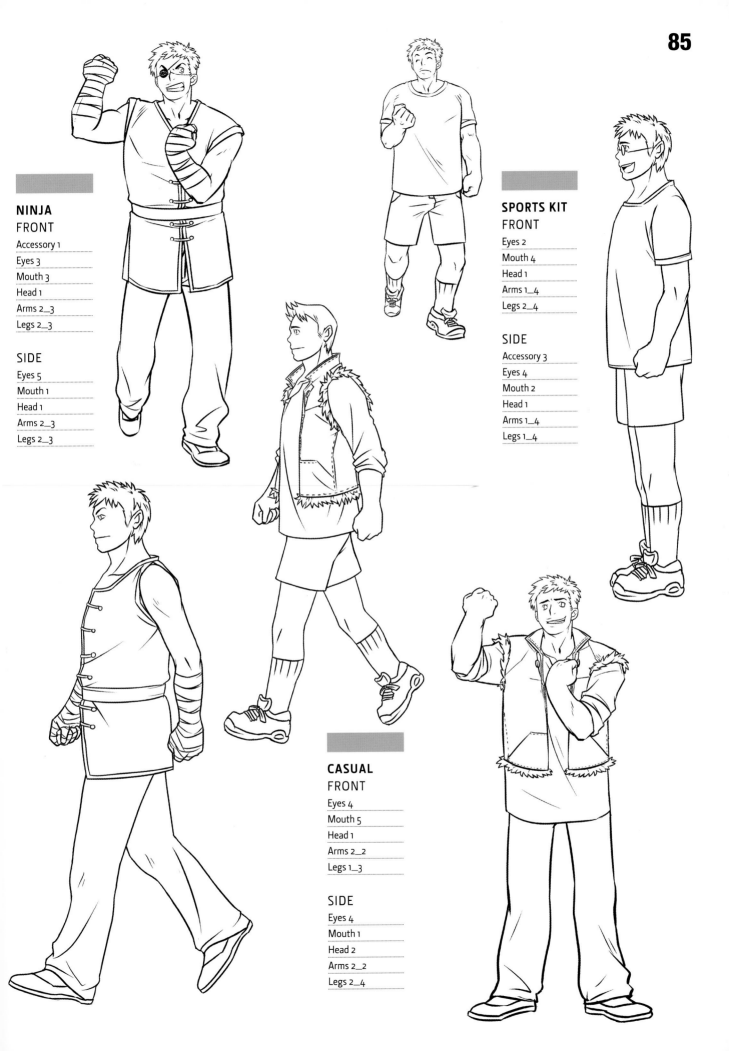

NINJA
FRONT
Accessory 1
Eyes 3
Mouth 3
Head 1
Arms 2_3
Legs 2_3

SIDE
Eyes 5
Mouth 1
Head 1
Arms 2_3
Legs 2_3

SPORTS KIT
FRONT
Eyes 2
Mouth 4
Head 1
Arms 1_4
Legs 2_4

SIDE
Accessory 3
Eyes 4
Mouth 2
Head 1
Arms 1_4
Legs 1_4

CASUAL
FRONT
Eyes 4
Mouth 5
Head 1
Arms 2_2
Legs 1_3

SIDE
Eyes 4
Mouth 1
Head 2
Arms 2_2
Legs 2_4

SHONEN

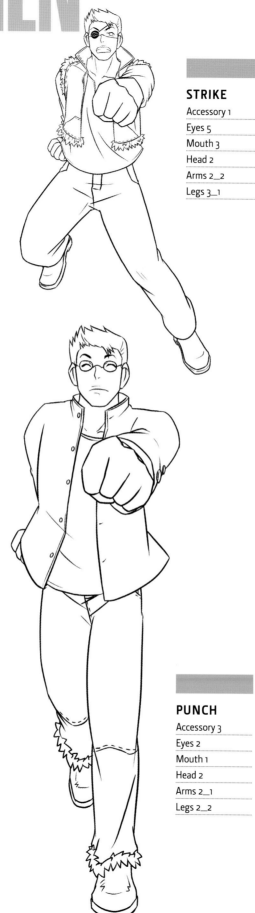

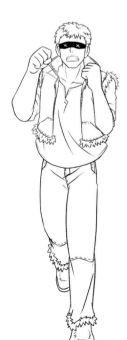

STRIKE

Accessory 1
Eyes 5
Mouth 3
Head 2
Arms 2_2
Legs 3_1

STANCE

Eyes 1
Mouth 5
Head 2
Arms 3_1
Legs

BLOCK

Accessory 2
Mouth 3
Head 1
Arms 1_2
Legs 2_1

PUNCH

Accessory 3
Eyes 2
Mouth 1
Head 2
Arms 2_1
Legs 2_2

ACTION LAYERS

	accessory 1
	accessory 2
	accessory 3
	accessory 4
	eyes 1
	eyes 2
	eyes 3
	eyes 4
	eyes 5
	mouth 1
	mouth 2
	mouth 3
	mouth 4
	mouth 5
	head 1
	head 2
	arms 1_1
	arms 1_2
	arms 1_3
	arms 2_1
	arms 2_2
	arms 2_3
	legs 1_1
	legs 1_2
	legs 1_3
	legs 2_1
	legs 2_2
	legs 2_3
	legs 3_1
	legs 3_2
	legs 3_3

SUPPORTING 2

FRONT LAYERS

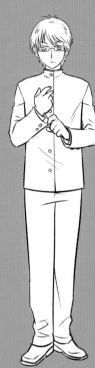 accessory 1	
accessory 2	
accessory 3	
accessory 4	
eyes 1	
eyes 2	
eyes 3	
eyes 4	
eyes 5	
mouth 1	
mouth 2	
mouth 3	
mouth 4	
mouth 5	
head 1	
head 2	
arms 1_1	
arms 1_2	
arms 1_3	
arms 1_4	
arms 2_1	
arms 2_2	
arms 2_3	
arms 2_4	
legs 1_1	
legs 1_2	
legs 1_3	
legs 1_4	
legs 2_1	
legs 2_2	
legs 2_3	
legs 2_4	

SCIENTIST
Accessory 1
Eyes 1
Mouth 1
Head 1
Arms 1_1
Legs 2_1

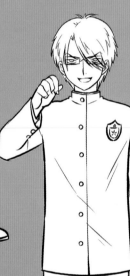

MAD NINJA
Accessory 3
Eyes 5
Mouth 1
Head 1
Arms 1_3
Legs 1_3

BIKER
Eyes 5
Mouth 3
Head 2
Arms 2_2
Legs 1_2

SCHOOLBOY
Accessory 1 + 2
Eyes 3
Mouth 2
Head 2
Arms 2_1
Legs 2_3

SHONEN

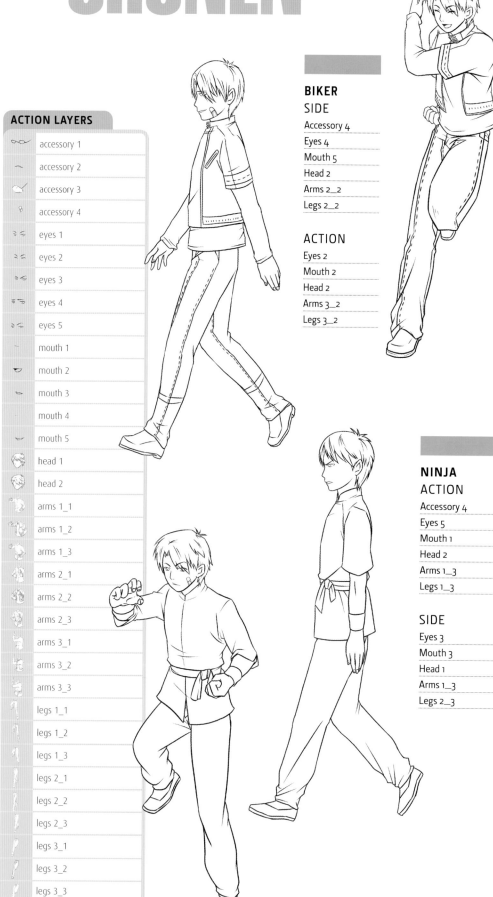

ACTION LAYERS

⌐	accessory 1
~	accessory 2
✎	accessory 3
⌐	accessory 4
≥⊆	eyes 1
≥⊆	eyes 2
≥⊆	eyes 3
≥⊳	eyes 4
≥⊆	eyes 5
⌐	mouth 1
⊽	mouth 2
⌐	mouth 3
⌐	mouth 4
⌐	mouth 5
🙂	head 1
🙂	head 2
✋	arms 1_1
✊	arms 1_2
✋	arms 1_3
✋	arms 2_1
✋	arms 2_2
✋	arms 2_3
✋	arms 3_1
✋	arms 3_2
✋	arms 3_3
🦵	legs 1_1
🦵	legs 1_2
🦵	legs 1_3
🦵	legs 2_1
🦵	legs 2_2
🦵	legs 2_3
🦵	legs 3_1
🦵	legs 3_2
🦵	legs 3_3

BIKER
SIDE
Accessory 4
Eyes 4
Mouth 5
Head 2
Arms 2_2
Legs 2_2

ACTION
Eyes 2
Mouth 2
Head 2
Arms 3_2
Legs 3_2

NINJA
ACTION
Accessory 4
Eyes 5
Mouth 1
Head 2
Arms 1_3
Legs 1_3

SIDE
Eyes 3
Mouth 3
Head 1
Arms 1_3
Legs 2_3

SIDE LAYERS

⌐	accessory 1
🔥	accessory 2
✎	accessory 3
⌐	accessory 4
⌐	eyes 1
⌐	eyes 2
⌐	eyes 3
⊽	eyes 4
⌐	eyes 5
⌐	mouth 1
⌐	mouth 2
⌐	mouth 3
⌐	mouth 4
⌐	mouth 5
🙂	head 1
🙂	head 2
🦵	arms 1_1
🦵	arms 1_2
🦵	arms 1_3
🦵	arms 2_1
🦵	arms 2_2
🦵	arms 2_3
🦵	legs 1_1
🦵	legs 1_2
🦵	legs 1_3
🦵	legs 1_4
🦵	legs 2_1
🦵	legs 2_2
🦵	legs 2_3
🦵	legs 2_4

SCIENTIST
ACTION
Accessory 1 +3
Eyes 3
Mouth 1
Head 2
Arms 1_1
Legs 3_1

SIDE
Accessory 1, 2 + 3
Eyes 5
Head 2
Arms 1_1
Legs 1_1

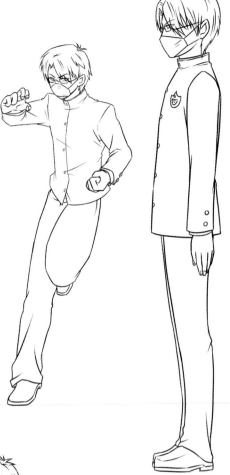

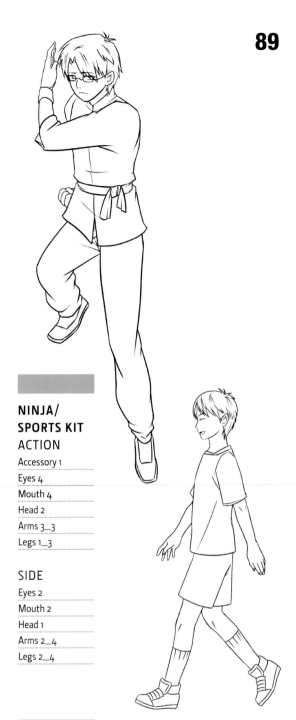

NINJA/ SPORTS KIT
ACTION
Accessory 1
Eyes 4
Mouth 4
Head 2
Arms 3_3
Legs 1_3

SIDE
Eyes 2
Mouth 2
Head 1
Arms 2_4
Legs 2_4

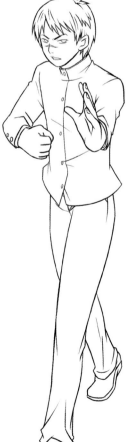

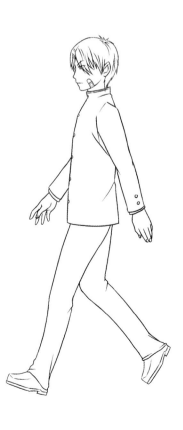

UNIFORM
ACTION
Accessory 2
Eyes 3
Mouth 3
Head 1
Arms 2_1
Legs 2_1

SIDE
Accessory 4
Eyes 1
Mouth 1
Head 2
Arms 2_1
Legs 2_1

SHONEN

SUPPORTING 3

FRONT LAYERS

	accessory 1
	accessory 2
	eyes 1
	eyes 2
	eyes 3
	eyes 4
	eyes 5
	mouth 1
	mouth 2
	mouth 3
	mouth 4
	mouth 5
	head 1
	head 2
	arms 1_1
	arms 1_2
	arms 2_1
	arms 2_2
	arms 3_1
	arms 3_2
	arms 4_1
	arms 4_2
	legs 1_1
	legs 1_2
	legs 2_1
	legs 2_2

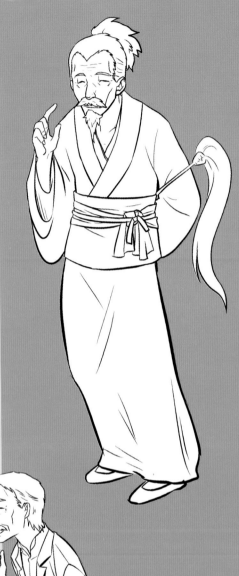

SENSEI
FRONT
Accessory 1
Eyes 2
Mouth 3
Head 1
Arms 1_2
Legs 1_2

SIDE
Eyes 3
Mouth 3
Head 2
Arms 2_2
Legs 2_2

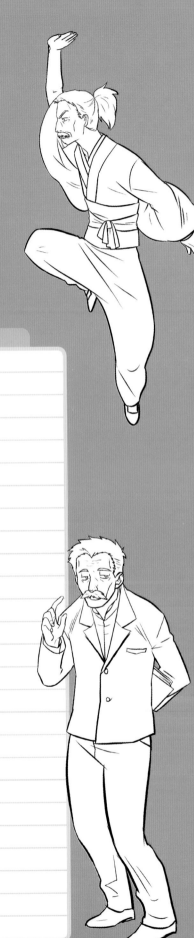

SIDE LAYERS

	accessory 1
	accessory 2
	eyes 1
	eyes 2
	eyes 3
	eyes 4
	eyes 5
	mouth 1
	mouth 2
	mouth 3
	mouth 4
	mouth 5
	head 1
	head 2
	arms 1_1
	arms 1_2
	arms 2_1
	arms 2_2
	arms 3_1
	arms 3_2
	arms 4_1
	arms 4_2
	legs 1_1
	legs 1_2
	legs 2_1
	legs 2_2

TEACHER
FRONT
Accessory 2
Eyes 1
Mouth 2
Head 1
Arms 1_1
Legs 1_1

SIDE
Accessory 2
Eyes 2
Mouth 2
Head 1
Arms 1_1
Legs 1_1

NINJA
MASTER
FRONT
Eyes 1
Mouth 5
Head 1
Arms 4_2
Legs 2_2

SIDE
Accessory 1
Eyes 5
Mouth 1
Head 2
Arms 1_2
Legs 1_2

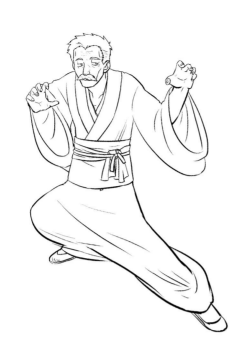
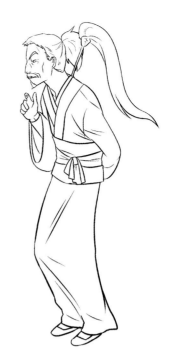

ACTION
SENSAI
FRONT
Eyes 3
Mouth 4
Head 2
Arms 3_2
Legs 2_2

SIDE
Eyes 5
Mouth 1
Head 2
Arms 3_2
Legs 2_2

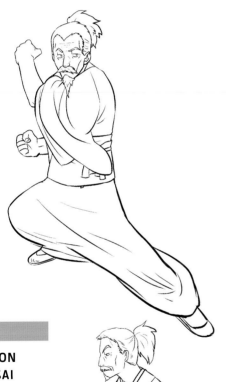

ACTION
TEACHER
FRONT
Eyes 3
Mouth 2
Head 2
Arms 4_1
Legs 2_1

SIDE
Eyes 4
Mouth 4
Head 1
Arms 4_1
Legs 2_1

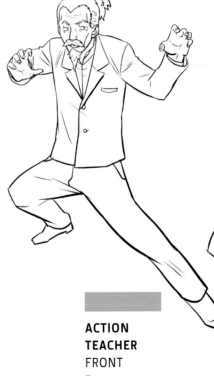

SHONEN

SUPPORTING 4

FRONT LAYERS

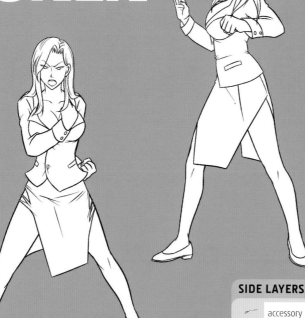	accessory 1
	accessory 2
	eyes 1
	eyes 2
	eyes 3
	eyes 4
	eyes 5
	mouth 1
	mouth 2
	mouth 3
	mouth 4
	mouth 5
	head 1
	head 2
	arms 1_1
	arms 1_2
	arms 2_1
	arms 2_2
	arms 3_1
	arms 3_2
	arms 4_1
	arms 4_2
	legs 1_1
	legs 1_2
	legs 2_1
	legs 2_2

ACTION
OFFICE
SIDE
Accessory 1
Eyes 5
Mouth 2
Head 1
Arms 3_1
Legs 2_1

FRONT
Eyes 3
Mouth 3
Head 1
Arms 3_1
Legs 2_1

SIDE LAYERS

	accessory 1
	accessory 2
	eyes 1
	eyes 2
	eyes 3
	eyes 4
	eyes 5
	mouth 1
	mouth 2
	mouth 3
	mouth 4
	mouth 5
	head 1
	head 2
	arms 1_1
	arms 1_2
	arms 2_1
	arms 2_2
	arms 3_1
	arms 3_2
	arms 4_1
	arms 4_2
	legs 1_1
	legs 1_2
	legs 2_1
	legs 2_2

FEMME
FATALE
SIDE
Eyes 2
Mouth 3
Head 2
Arms 1_2
Legs 1_2

FRONT
Accessory 1
Eyes 2
Mouth 2
Head 1
Arms 1_2
Legs 1_2

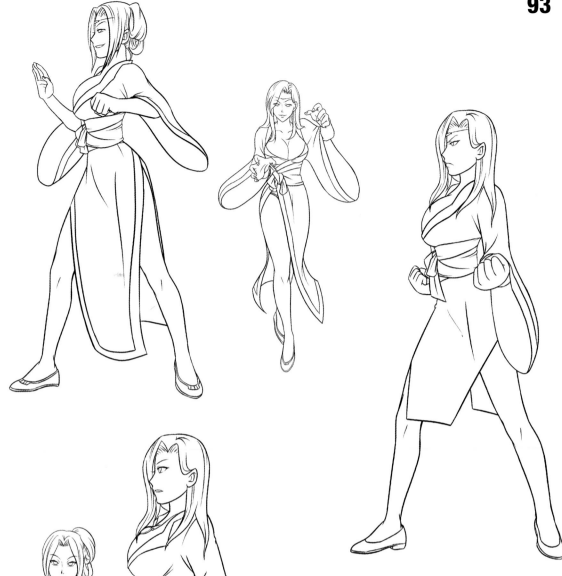

**ACTION
NINJA**
SIDE

Accessory 1

Eyes 5

Mouth 5

Head 2

Arms 3_2

Legs 2_2

FRONT

Accessory 1

Eyes 5

Mouth 5

Head 1

Arms 4_2

Legs 1_2

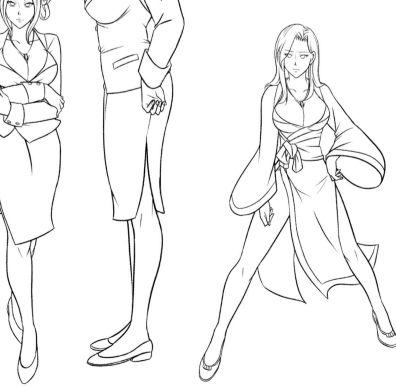

OFFICE
FRONT

Accessory 2

Eyes 1

Mouth 1

Head 2

Arms 1_1

Legs 1_1

SIDE

Accessory 2

Eyes 1

Mouth 1

Head 1

Arms 2_1

Legs 1_1

**STANCE
NINJA**
SIDE

Accessory 1

Eyes 3

Mouth 4

Head 1

Arms 4_1

Legs 2_1

FRONT

Accessory 2

Eyes 4

Mouth 4

Head 1

Arms 2_2

Legs 2_2

SHONEN
PAGE LAYOUT TEMPLATES

EVERY PAGE STARTS WITH THE LAYING-OUT OF PANELS.
IN THIS SECTION YOU'LL FIND A WIDE VARIETY OF
OPTIONS, ALL PERFECTLY SIZED FOR PROFESSIONAL
MANGA, AND ORGANIZED BY THE INCREASING NUMBER
OF PANELS AND LAYOUT COMPLEXITY. FLIP THE LAYOUTS
HORIZONTALLY AND VERTICALLY TO INCREASE YOUR
VISUAL VARIETY.

ONE PANEL **TWO PANELS**

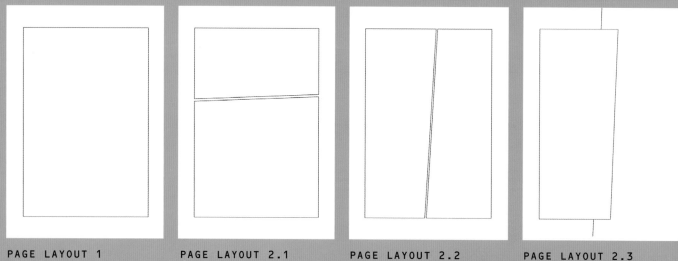

PAGE LAYOUT 1 PAGE LAYOUT 2.1 PAGE LAYOUT 2.2 PAGE LAYOUT 2.3

PAGE LAYOUT 2.4 PAGE LAYOUT 2.5 PAGE LAYOUT 2.6

THREE PANELS

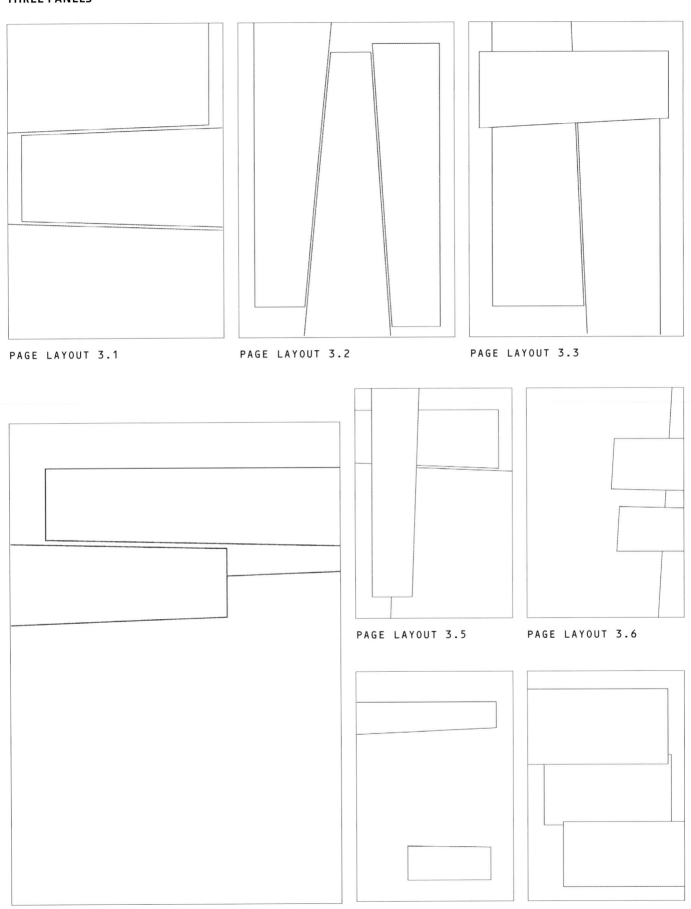

PAGE LAYOUT 3.1

PAGE LAYOUT 3.2

PAGE LAYOUT 3.3

PAGE LAYOUT 3.4

PAGE LAYOUT 3.5

PAGE LAYOUT 3.6

PAGE LAYOUT 3.7

PAGE LAYOUT 3.8

SHONEN

FOUR PANELS

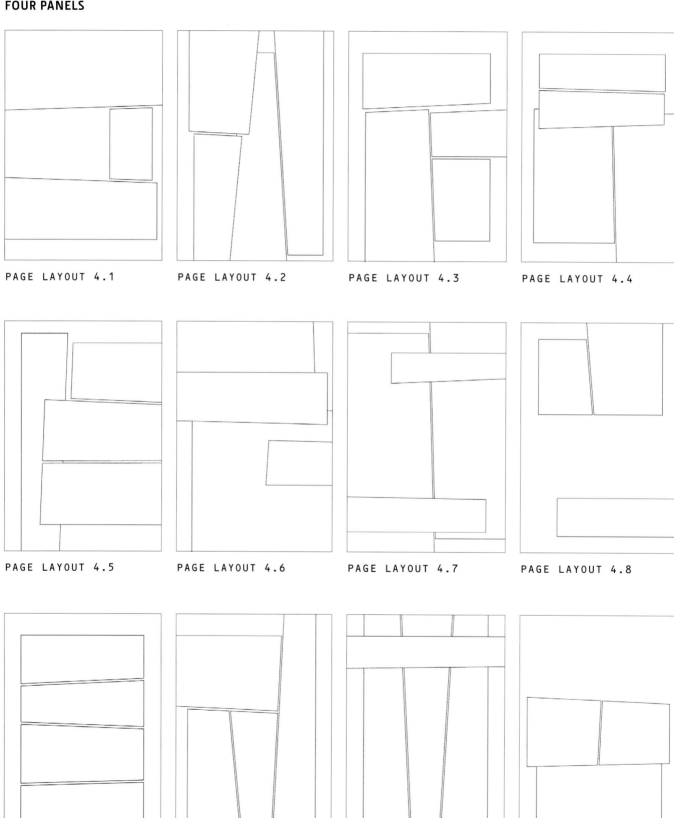

PAGE LAYOUT 4.1

PAGE LAYOUT 4.2

PAGE LAYOUT 4.3

PAGE LAYOUT 4.4

PAGE LAYOUT 4.5

PAGE LAYOUT 4.6

PAGE LAYOUT 4.7

PAGE LAYOUT 4.8

PAGE LAYOUT 4.9

PAGE LAYOUT 4.10

PAGE LAYOUT 4.11

PAGE LAYOUT 4.12

FIVE PANELS

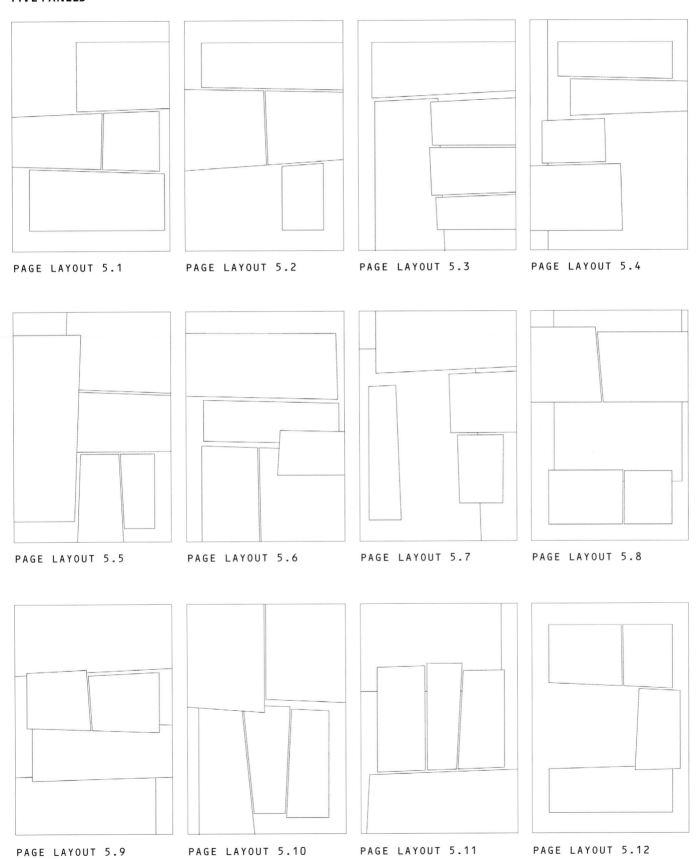

PAGE LAYOUT 5.1 PAGE LAYOUT 5.2 PAGE LAYOUT 5.3 PAGE LAYOUT 5.4

PAGE LAYOUT 5.5 PAGE LAYOUT 5.6 PAGE LAYOUT 5.7 PAGE LAYOUT 5.8

PAGE LAYOUT 5.9 PAGE LAYOUT 5.10 PAGE LAYOUT 5.11 PAGE LAYOUT 5.12

SHONEN

SIX PANELS

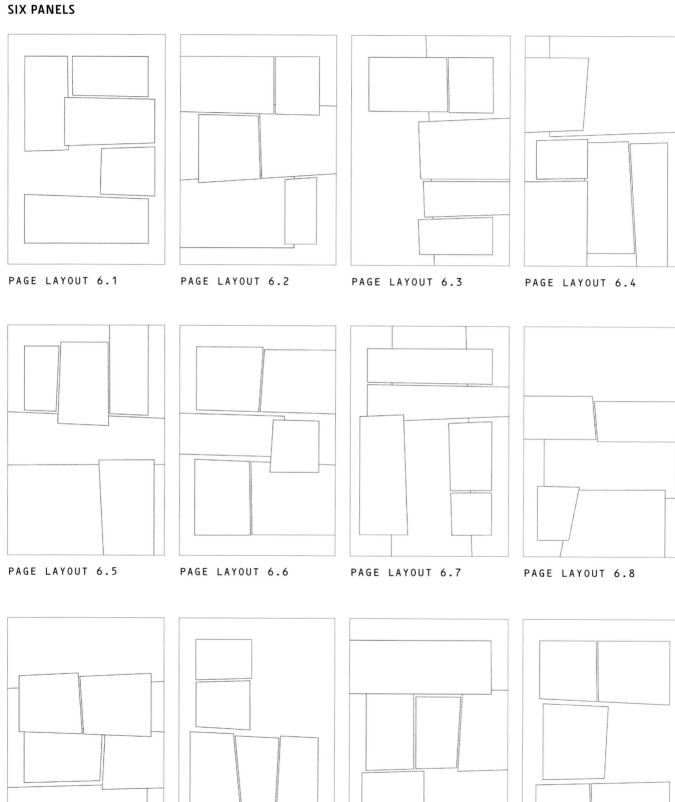

PAGE LAYOUT 6.1

PAGE LAYOUT 6.2

PAGE LAYOUT 6.3

PAGE LAYOUT 6.4

PAGE LAYOUT 6.5

PAGE LAYOUT 6.6

PAGE LAYOUT 6.7

PAGE LAYOUT 6.8

PAGE LAYOUT 6.9

PAGE LAYOUT 6.10

PAGE LAYOUT 6.11

PAGE LAYOUT 6.12

SEVEN OR MORE PANELS

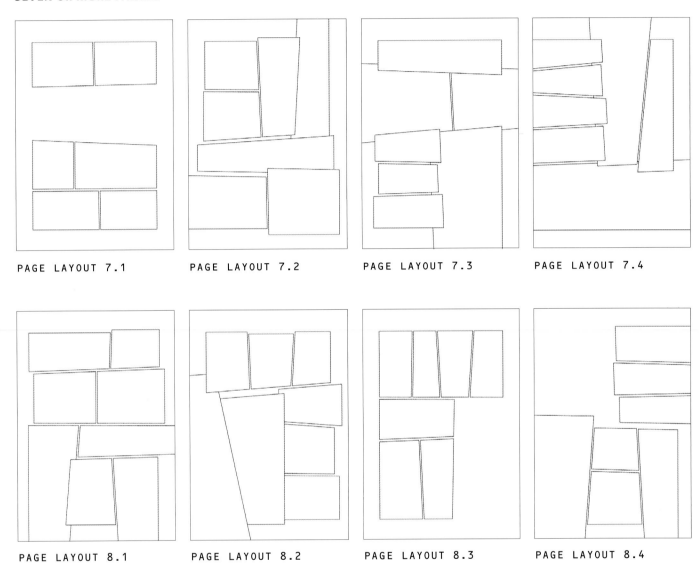

PAGE LAYOUT 7.1

PAGE LAYOUT 7.2

PAGE LAYOUT 7.3

PAGE LAYOUT 7.4

PAGE LAYOUT 8.1

PAGE LAYOUT 8.2

PAGE LAYOUT 8.3

PAGE LAYOUT 8.4

PAGE LAYOUT 8.5

SHONEN

WORD BALLOONS AND CAPTION BOXES

SHONEN CHARACTERS ALWAYS HAVE A LOT TO SAY FOR THEMSELVES—SO MAKE SURE THEY ALWAYS HAVE SOMETHING TO CAPTURE THEIR WORDS! HERE'S A FLOTILLA OF BALLOONS FOR EVERY OCCASION, FROM CURVED ELLIPSES TO RECTANGULAR AND JAGGED ITERATIONS. SQUASH AND STRETCH THESE BALLOONS BY RESIZING THEM IN PHOTOSHOP TO ENSURE YOUR WORDS ARE ALWAYS A PERFECT FIT.

ANNOUNCEMENT

CHEERFUL

HAPPY

SURPRISE

INSECURE

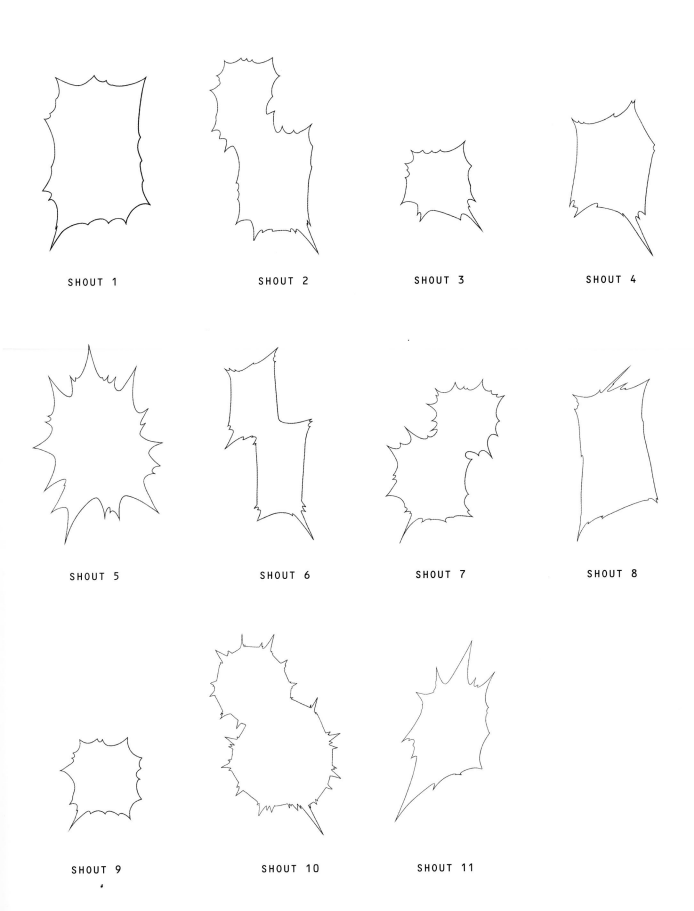

SHOUT 1

SHOUT 2

SHOUT 3

SHOUT 4

SHOUT 5

SHOUT 6

SHOUT 7

SHOUT 8

SHOUT 9

SHOUT 10

SHOUT 11

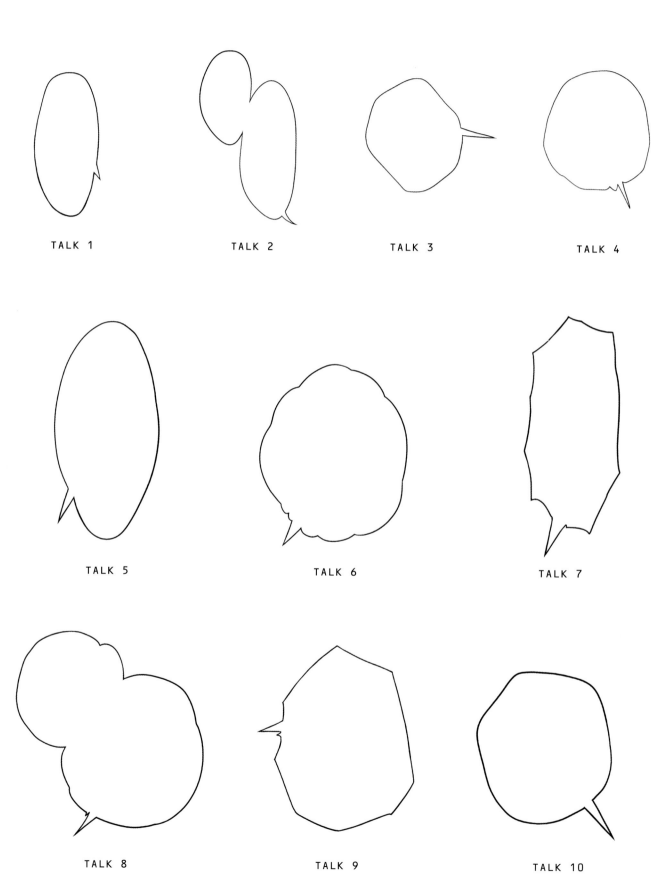

TALK 1

TALK 2

TALK 3

TALK 4

TALK 5

TALK 6

TALK 7

TALK 8

TALK 9

TALK 10

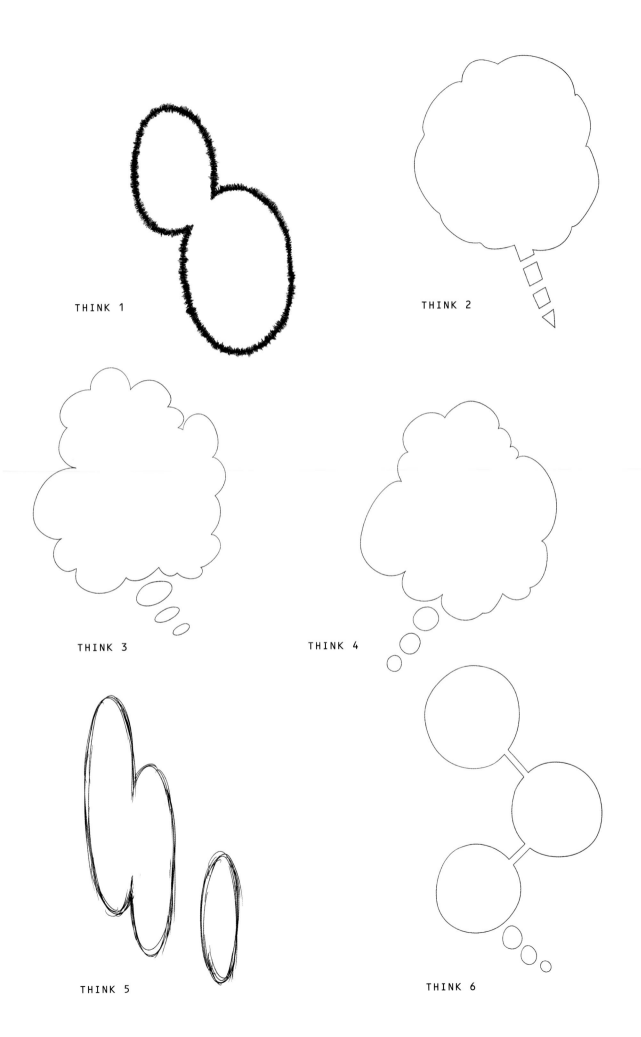

THINK 1

THINK 2

THINK 3

THINK 4

THINK 5

THINK 6

SHONEN
SPEEDLINES AND FOCUS LINES

SPEEDLINES AND FOCUS LINES ADD TENSION AND
DYNAMISM TO ANY PAGE, SHINING A SPOTLIGHT
ONTO AN EMOTIONAL MOMENT, OR BRINGING
AN UNFORGETTABLE MOTORCYCLE CHASE TO LIFE.
THE PATTERNS ON THE DISC CAN BE CUT, CROPPED,
ROTATED, AND PLACED ONTO YOUR PAGES HOWEVER
YOU SEE FIT. TRY OVERLAPPING THEM WITH YOUR
ART ON A SEPARATE LAYER.

SPEEDLINE 1

SPEEDLINE 3

SPEEDLINE 4

SPEEDLINE 2

SPEEDLINE 5

SPEEDLINE 6

SPEEDLINE 7

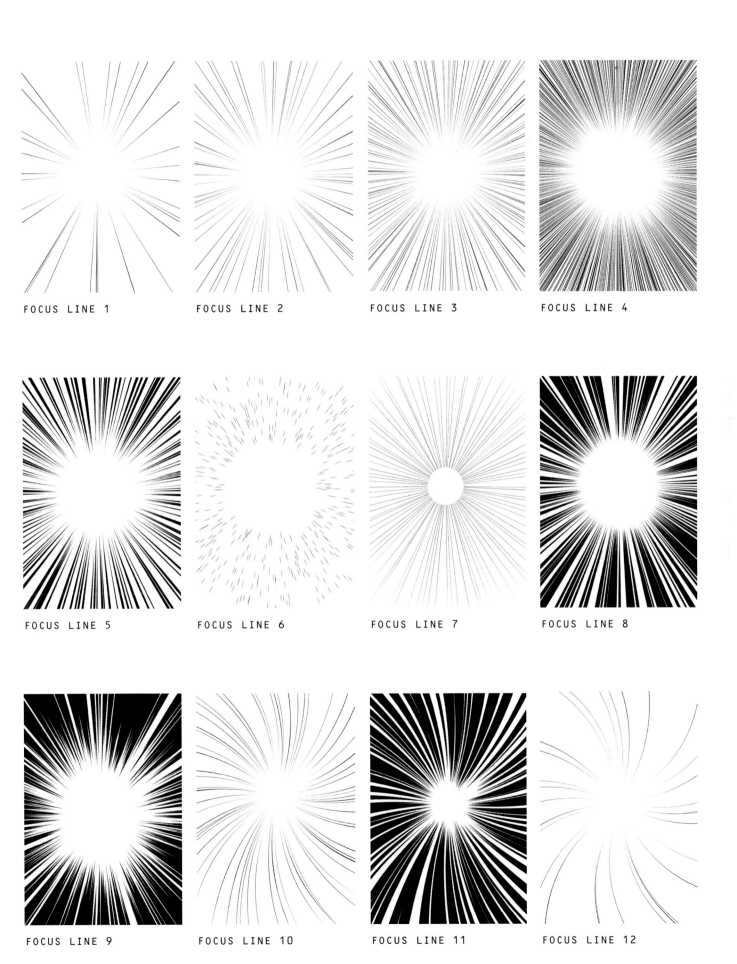

FOCUS LINE 1

FOCUS LINE 2

FOCUS LINE 3

FOCUS LINE 4

FOCUS LINE 5

FOCUS LINE 6

FOCUS LINE 7

FOCUS LINE 8

FOCUS LINE 9

FOCUS LINE 10

FOCUS LINE 11

FOCUS LINE 12

TONES SHONEN

BLACK AND WHITE MANGA THRIVES ON TONES, AND YOU'LL FIND AN UNMATCHED SELECTION HERE: EVERYTHING FROM SIMPLE GRADATIONS TO STARBURSTS, ELECTRICAL ARCS, AND MORE! LOAD A TONE INTO THE PATTERN FILL TOOL IN PHOTOSHOP AND FILL TARGETED AREAS, OR PASTE A PATTERN TO A NEW LAYER AND CREATE DIFFERENT BACKGROUND EFFECTS.

ACTION TONE 1

ACTION TONE 2

ACTION TONE 3

ACTION TONE 4

ACTION TONE 5

ACTION TONE 6

ACTION TONE 7

ACTION TONE 8

ACTION TONE 9

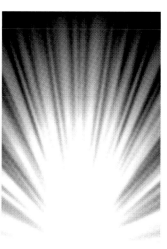

ACTION TONE 10

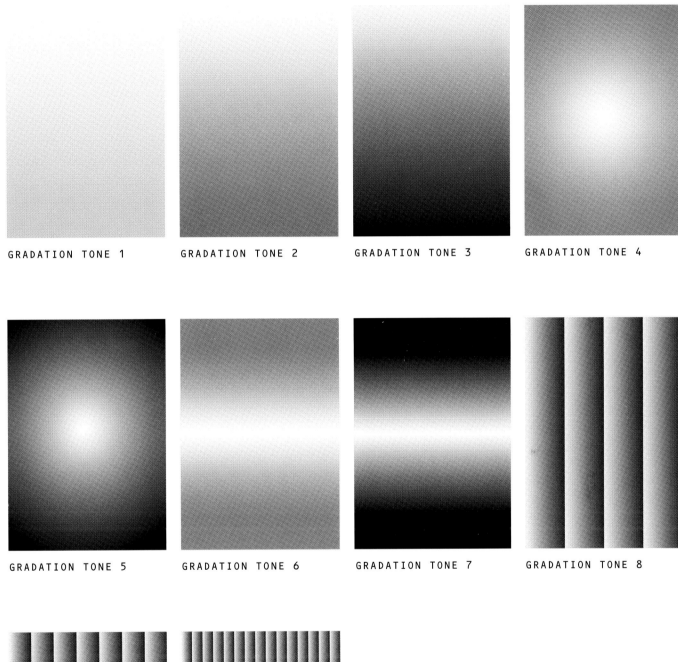

GRADATION TONE 1

GRADATION TONE 2

GRADATION TONE 3

GRADATION TONE 4

GRADATION TONE 5

GRADATION TONE 6

GRADATION TONE 7

GRADATION TONE 8

GRADATION TONE 9

GRADATION TONE 10

GRAYTONE 1

GRAYTONE 2

GRAYTONE 3

GRAYTONE 4

GRAYTONE 5

GRAYTONE 6

GRAYTONE 7

GRAYTONE 8

GRAYTONE 9

GRAYTONE 10

GRAYTONE 11

GRAYTONE 12

GRAYTONE 13

GRAYTONE 14

GRAYTONE 15

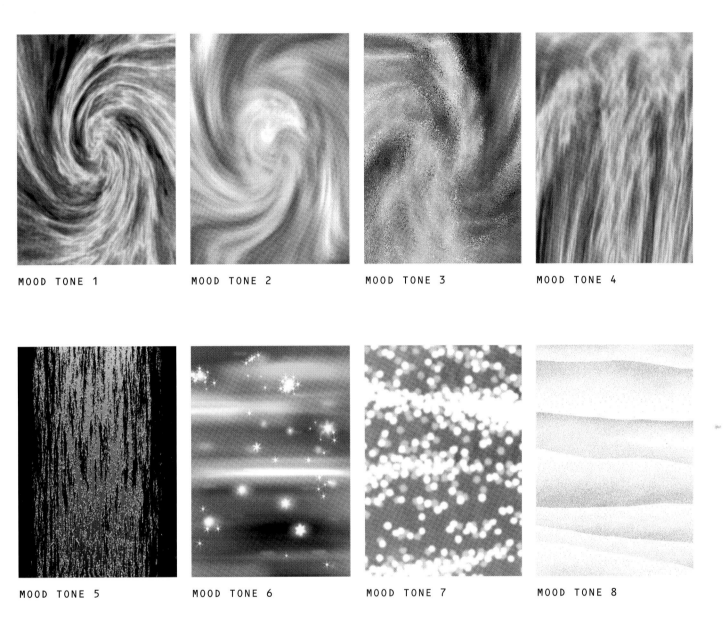

MOOD TONE 1

MOOD TONE 2

MOOD TONE 3

MOOD TONE 4

MOOD TONE 5

MOOD TONE 6

MOOD TONE 7

MOOD TONE 8

MOOD TONE 9

MOOD TONE 10

03 //
BACKGROUNDS
AND ACCESSORIES

BACKGROUNDS PROVIDE THE SETTING FOR YOUR STORY.
IN TIME YOU MAY WANT TO CREATE YOUR OWN FROM
SCRATCH OR USING A PHOTOGRAPH. HERE'S A SELECTION
TO START YOU OFF, WITH SCENE SUGGESTIONS, AS WELL
AS A GALLERY OF WEAPONS AND ACCESSORIES WITH
WHICH TO SPICE UP YOUR STRIP!

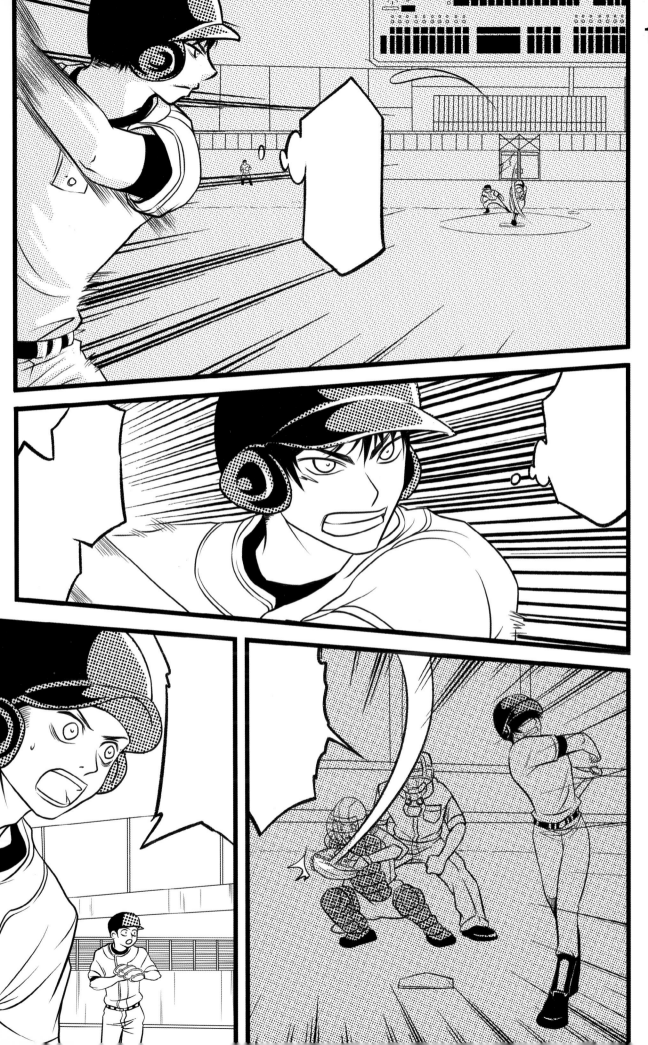

SHONEN BACKGROUNDS

INCLUDING BACKGROUNDS IN YOUR MANGA PAGES IS ESSENTIAL—NOT ONLY DO THEY HELP YOUR READER FOLLOW YOUR STORY, THEY ALSO SHOWCASE THE SETTING AND SITUATION OF YOUR CHARACTERS. ESTABLISHING PANELS—THE FIRST TIME A NEW LOCATION IS SHOWN—WILL BE RELATIVELY BIG, FEATURING LOTS OF THE BACKGROUND ARTWORK, WHEREAS SMALLER, CLOSE-UP PANELS COULD SHOW SMALL DETAILS WITHIN THE BACKGROUND, OR IN SOME CASES SIMPLY BE LEFT BLANK, ESPECIALLY IF YOU'RE USING WASHES OF COLOR OR TONE TO SUGGEST DETAIL.

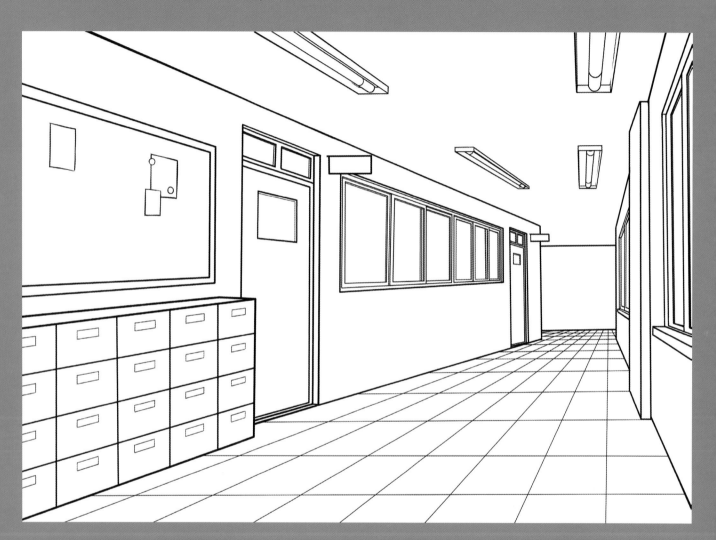

SCHOOL HALLWAY
The hallway is the epicenter of school politics: where after hours fights or sports matches are organized, friends are formed, and enemies are made. Or is that a coded letter on the notice board, leading to adventure?

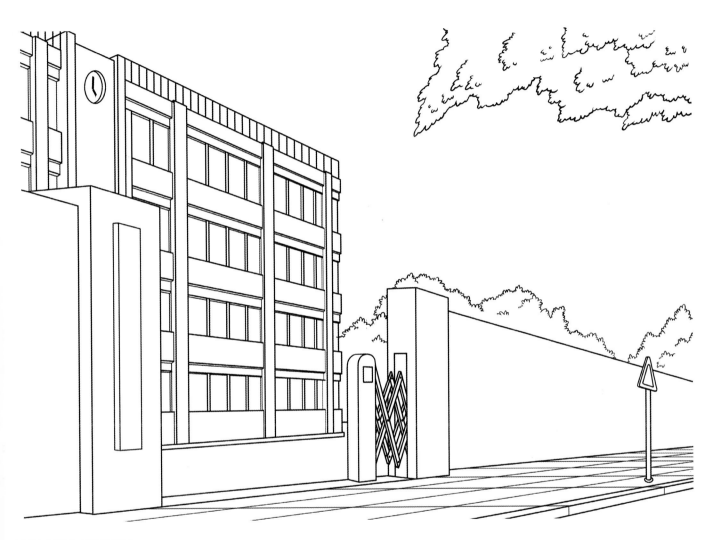

BUILDING GROUNDS

Once the clock strikes and the final bell rings to mark the end of the school day, your hero is free to embark on his mission. Although this doesn't have to be a school—it could be an abandoned warehouse, or a tightly guarded laboratoy.

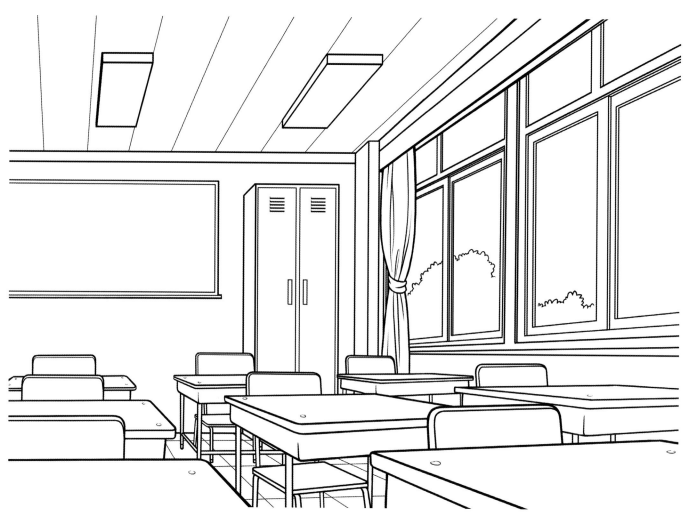

CLASSROOM

A place for illicit notes to be passed, plans hatched,
teachers baited, lessons struggled through, or
hyper-intelligent wits matched on the whiteboard.

MARTIAL ARTS ROOM

Tomorrow's ninja today! From dummies riddled with throwing stars to teenagers dueling silently on floorboards designed to creak under the slightest pressure, here the assassins and spies of the future are pushed through their paces.

SOCCER PITCH

Passes are fumbled and plays are made, scholarships are won and relationships broken. Strut out on the gridiron and play some ball!

BASKETBALL COURT
With adrenaline-fueled pulses running high,
the basketball court is the perfect setting for
a showdown between two sporting rivals.

JUNGLE

The perfect spot for a remote camping trip—or a battle against demonic forces? What unknown creatures or spirits lurk in the depths of the forest—and how far is it to the nearest service station, we're starving!

TEMPLE

After arduous climbs up sheer mountains,
exhausting treks across valleys, and ambushes
from sword-throwing ninjas, you finally reach
the sacred temple. Or is it the dragon's den?

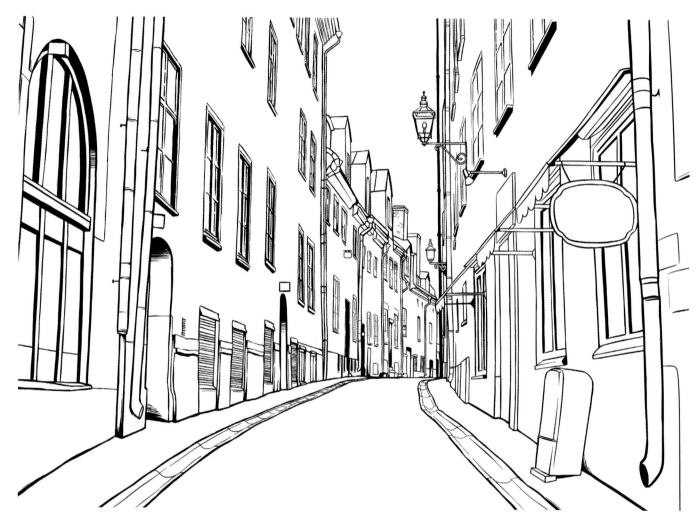

BACK ALLEY

Your heroes have strayed off the beaten path and
into a thin and narrow cut between two buildings:
Will they make it out alive? Will they be mugged,
and fight back? Will they see something horrific,
feasting in the shadows?

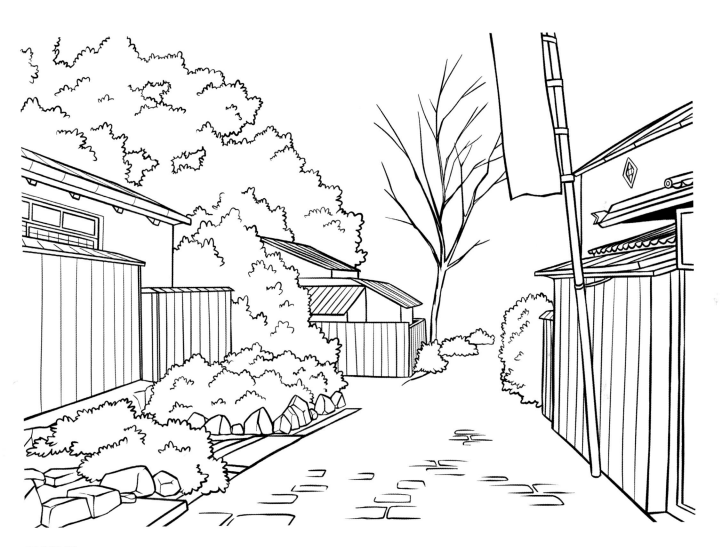

PATHWAY

A place to hang out, a place to pass through—it's
all these things and more. Think about how streets
change when night falls and the undesirables come out
to play. What could be a respectable corner at 10 in the
morning could be a biker gang haven after sunset.

SHONEN
ACCESSORIES

ACCESSORIES ARE A GREAT WAY TO PERSONALIZE AND INDIVIDUALIZE YOUR CHARACTERS STILL FURTHER, EVEN IF IT'S JUST BY PLACING THEM IN A COUPLE OF PANELS AS YOU SWEEP THROUGH THEIR HOME—A GUITAR OR CHOICE OF BOOKS CAN TELL YOU A LOT ABOUT A PERSON, AS CAN GADGETS, SPORTING GEAR, ART EQUIPMENT, AND THE LIKE. QUITE ASIDE FROM THAT, THINK ABOUT THE ACCOUTREMENTS THEY'LL LUG AROUND WITH THEM ON A DAILY BASIS—FROM THE LATEST IPOD TO A FOLD-UP BRIEFCASE CONTAINING THEIR MECH CONTROL HELMET.

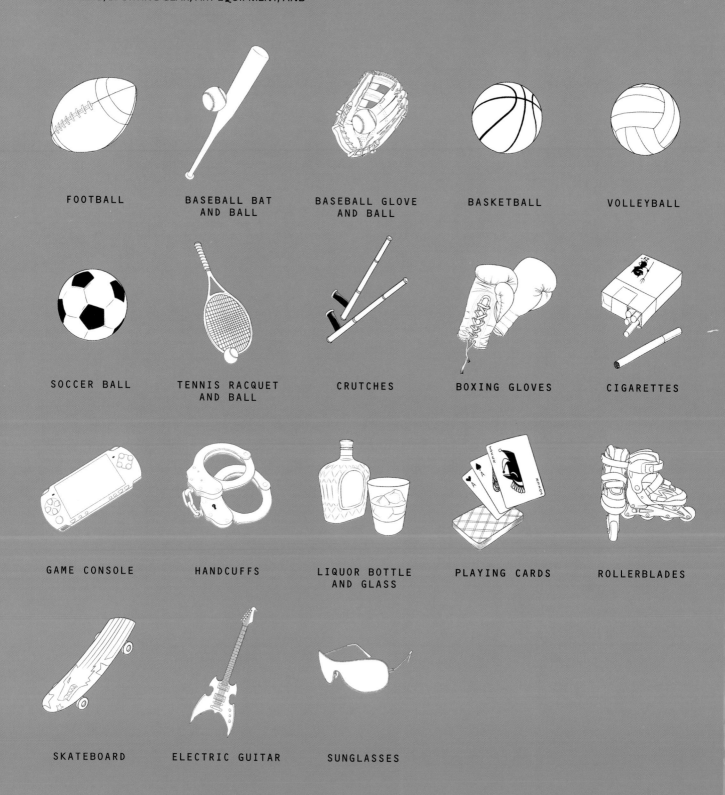

FOOTBALL

BASEBALL BAT
AND BALL

BASEBALL GLOVE
AND BALL

BASKETBALL

VOLLEYBALL

SOCCER BALL

TENNIS RACQUET
AND BALL

CRUTCHES

BOXING GLOVES

CIGARETTES

GAME CONSOLE

HANDCUFFS

LIQUOR BOTTLE
AND GLASS

PLAYING CARDS

ROLLERBLADES

SKATEBOARD

ELECTRIC GUITAR

SUNGLASSES

WEAPONS

WHILE SOME OF THE BEST SHONEN HEROES ARE THOSE WHO SHOW THEIR PROWESS IN SPORTS, WHO DEFEAT THEIR ENEMIES UNARMED, OR WHO MATCH THEIR OPPONENTS IN CONTESTS OF WITS, THERE ARE JUST AS MANY SHONEN ADVENTURES THAT FEATURE FUTURISTIC, BIZARRE, FANTASTICAL, OR OUTLANDISH WEAPONRY. HERE IS A SMALL SELECTION OF WEAPONRY TO GET YOU GOING—TRY COMBINING A COUPLE TO PRODUCE AN ALL-NEW ITEM!

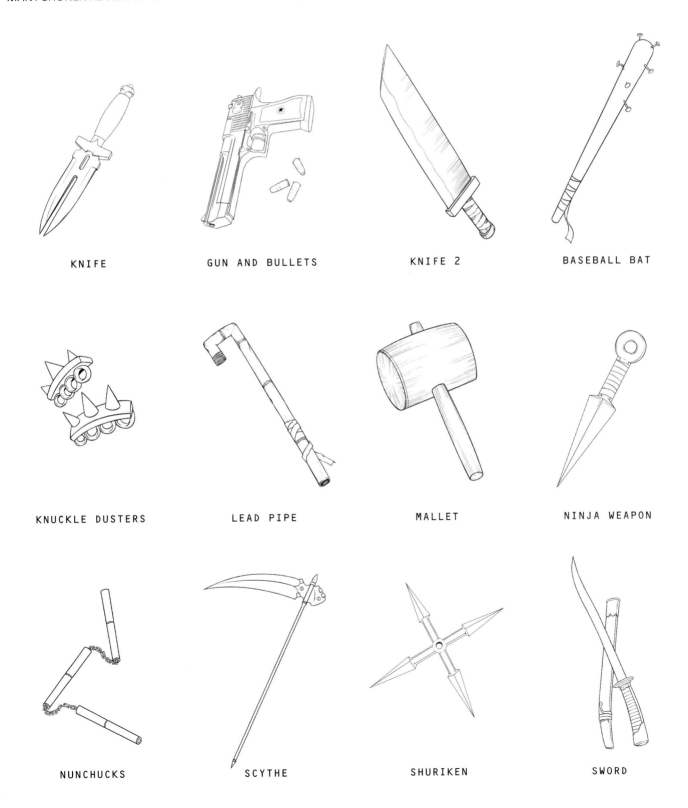

KNIFE

GUN AND BULLETS

KNIFE 2

BASEBALL BAT

KNUCKLE DUSTERS

LEAD PIPE

MALLET

NINJA WEAPON

NUNCHUCKS

SCYTHE

SHURIKEN

SWORD

SHONEN

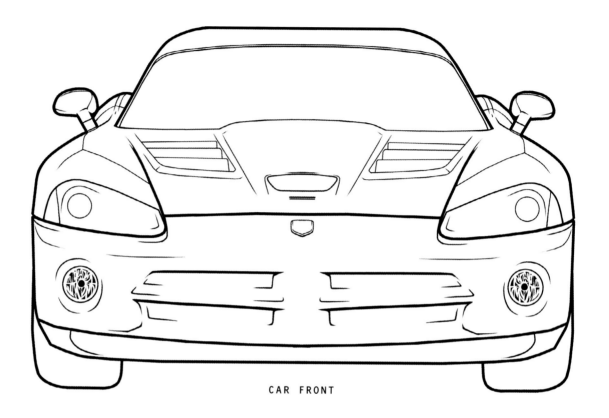

CAR FRONT

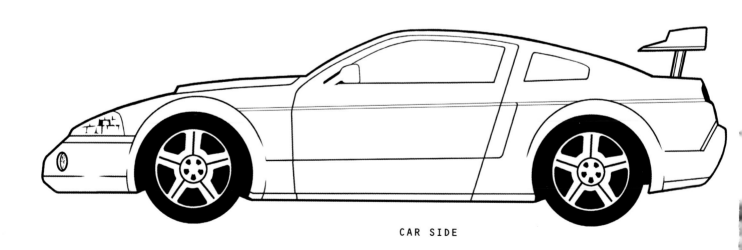

CAR SIDE

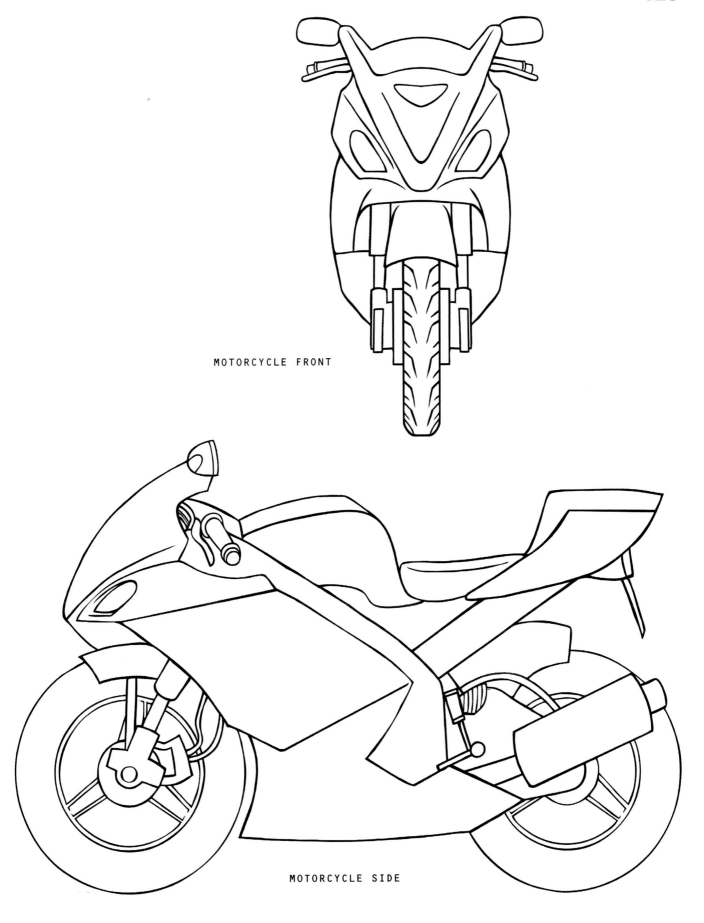

MOTORCYCLE FRONT

MOTORCYCLE SIDE

SHONEN

INDEX